950

ANCIEN

CULTE

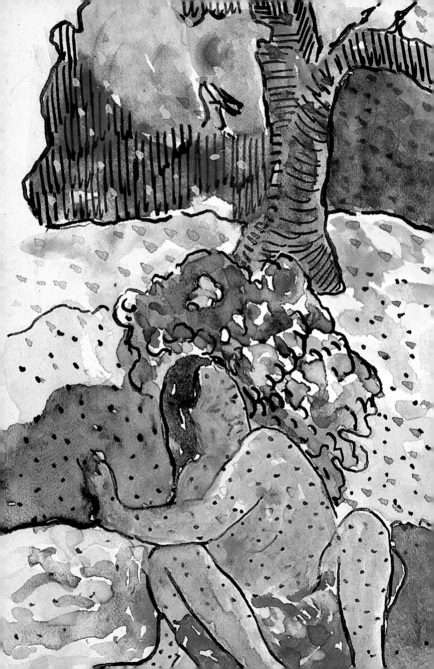

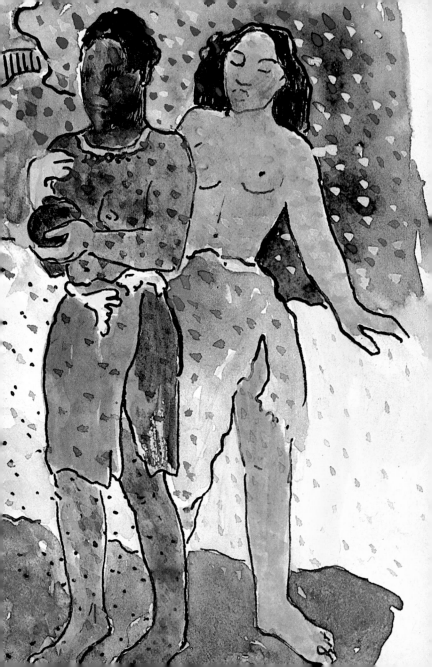

Son amaute que ava

de fruits et une cou

plus riches et des nattes

aresse un sac à charge

formée des étoffes les

es plus fines.

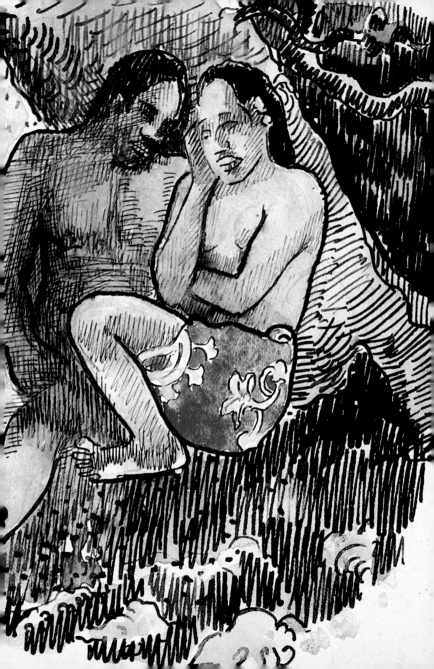

CONTENTS

GAUGUIN
THE QUEST FOR PARADISE

Françoise Cachin

DISCOVERIES
HARRY N. ABRAMS, INC., PUBLISHERS
NEW YORK

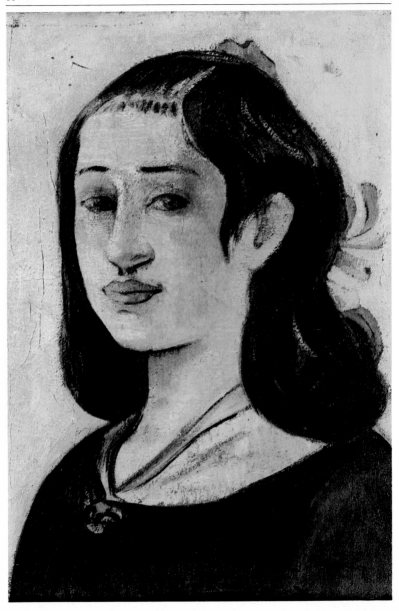

For centuries, choosing to be an artist was simply a matter of imitation. A painter-to-be carried on a tradition handed down from father to son. He'd spend his childhood posing and assisting as he breathed in the fumes of binders and turpentine. Apprenticeship was a family affair, and his first studio was under the family roof. Starting with the Romantic era, however, it was just the opposite for certain individuals. Their desire to be artists was an act of rebellion, and running away was part of a highly personal quest for identity. This was the case with Cézanne and Manet. Also Gauguin.

CHAPTER I
BECOMING AN ARTIST

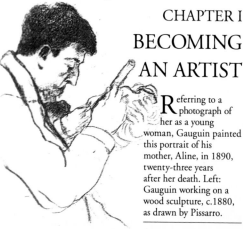

Referring to a photograph of her as a young woman, Gauguin painted this portrait of his mother, Aline, in 1890, twenty-three years after her death. Left: Gauguin working on a wood sculpture, c.1880, as drawn by Pissarro.

To single out history or sociology or psychoanalysis —indeed, any one factor—as the key to this mysterious process would be an oversimplification. The same parents and the same events do not produce identical personalities. But this much we must concede: Paul Gauguin's family history and childhood were anything but ordinary.

"My Grandmother Was an Odd Sort of Woman. Her Name Was Flora Tristan"

"Proudhon said she had a touch of genius. Since I have no way of knowing if this was so, I'll take Proudhon's word for it. She went in for all kinds of socialist activities and founded a workers' union.... It is probable that she did not know how to cook. A socialist bluestocking and an anarchist. She is credited with founding, together with Père Enfantin, trade unionism and a religion of her own called Mapa, with Enfantin as the god Ma and herself as the female deity Pa.

"I have never been able to sift out the truth, and I offer you all this for what it is worth. She died in 1844; many delegations followed her coffin.

"One thing I'm sure of, however, is that Flora Tristan was a very pretty, very noble lady. She was an intimate friend of Mme. Desbordes-Valmore. I also know for a fact that she used her entire fortune to further the workers' cause and traveled ceaselessly. Between times she went to Peru to see her uncle, Don Pio de Tristan y Moscoso (of an Aragonese family).

"Her daughter, who was my mother, was brought up entirely in the Pension Bascans, an essentially republican establishment. It was there that my father, Clovis Gauguin, made her acquaintance. At that time my father was the political correspondent for *Le National*, the paper run by Thiers and Armand Marast.

"After the events of 1848 (I was born 7 June 1848) did my father sense that the coup d'état of 1852 was coming? At any rate, he took it into his head to set out for Lima with the

In 1838 Flora Tristan (1803–44), below, heroine of romantic socialism, published an auto-biography with a title that must have captivated her roving, rebellious grandson: *The Wanderings of a Pariah.*

intention of starting a newspaper there. The young family was not without means.

"He had the misfortune to stumble upon a dreadful captain who did him terrible harm when he already had a serious heart condition. Just as he was starting to land at Port-Famine in the Strait of Magellan, he collapsed in the jollyboat and died of a ruptured aneurysm."

This account of the family saga, which Gauguin wrote in 1903, the year he died, is perfectly accurate except for the fictitious connection between his great-uncle and a family of Aragonese origin. He could have added that his maternal grandfather, André Chazal, tried to murder his wife in a fit of jealousy. Clearly, the men of the family were destined to violence, the women to exotic beauty.

An Exotic Childhood

Thus Gauguin spent the first years of his life, from 1849 to autumn 1854, in Peru.

"I have remarkable visual recall, and I remember this time in my life: our house, and ever so many things that happened, the monument of the presidency, the church

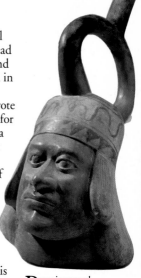

Peruvian vessel (above), and Lima in the 1800s.

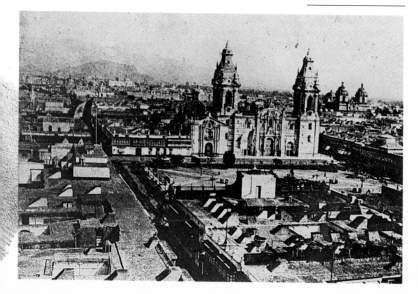

with the dome, added later, made entirely of wood.

"I can still see the little Negro girl who, as was customary, carried to church the little rug on which we knelt to pray. I can also see that Chinese servant of ours who was so clever at ironing. He was the one who found me in a grocery shop, sitting between two barrels of molasses, busily sucking sugarcane, while my weeping mother had them search high and low for me. I have always had the urge to run away like that. In Orléans, when I was nineteen, I took it into my head to run away to the forest of Bondy with a handkerchief full of sand at the end of a stick slung over my shoulder. It was a picture that had beguiled me—a traveler with his stick and bundle over his shoulder. Beware of pictures!"

Aline Gauguin returned to France with her six-year-old son and seven-year-old daughter—a sister Gauguin never mentions—to claim a legacy left by his paternal grandfather in Orléans, where the family now took up residence. Paul was an unexceptional pupil, already, as we have seen, succumbing to an irresistible urge to wander off on his own. Then again, how drab Europe must have seemed to a child used to being coddled by "colored" nannies! Surely compelling nostalgia had something to do with his departures for "the islands" in years to come.

Gauguin, Sailor and Stockbroker

In 1861 Aline moved to Paris and found work as a seamstress; her son joined her and prepared for the entrance exam at the Naval Academy. Once again, a lackluster showing: He failed to appear for the exam, and in December 1865, at the age of seventeen, enlisted as a "pilot's apprentice" (officer's candidate) in the Merchant Marine. Until 1871 he sailed the world over on virtually uninterrupted tours of duty to South America, the Mediterranean, and the frozen North. He was in India when he learned of his mother's death. She recommended in her will that her son "get on with his career, since he

Found among her son's papers, this photograph of Aline Gauguin as a young woman was the basis for Gauguin's posthumous portrait (see page 10), which accentuates her exotic appearance.

"How gracious and pretty my mother was when she donned her Lima attire, with the silk mantilla all but covering her face, revealing only one eye: Her gaze was so gentle, yet so compelling, so pure and affectionate."
Paul Gauguin,
Avant et Après

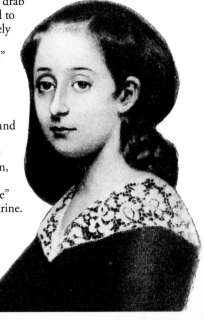

has made himself so unliked by all our friends that he will one day find himself all alone."

Fortunately, it did not come to that. When he arrived in Paris in 1872, this short ("1.6 meters tall," about 5'3", according to his registration book), stocky, sensitive lad got a helping hand from a friend of his mother's who had known Paul as a child: Gustave Arosa, financier, photographer, and collector of contemporary paintings.

Arosa arranged for him to enter the office of a stockbroker, and our sailor found himself working on the Paris Stock Exchange. He seems to have given a brilliant account of himself, because the following year he was in a position to ask for the hand of Mette Gad, a young Danish acquaintance of the Arosas, and start a family of his own: Emil was born in 1874, Aline in 1877, Clovis in 1879, Jean-René in 1881, and Paul in 1883. Gauguin moved them into increasingly comfortable apartments in which the studio assumed growing importance. For, like his legal guardian, Arosa, he collected art—Impressionist art, in particular—and did some painting.

Mette Gad and Paul Gauguin in 1873, the year they were married.

Seaman Gauguin sailed aboard the *Jérôme-Napoléon* from 1868 to 1870.

Part-time Painter: Pointers from Pissarro

Why and how did this young stockbroker and former sailor begin to paint? Frankly, we have no real answers to this pivotal question. We know that his first landscapes date to 1873–4 and that one of them was even exhibited at the Salon of 1876. We also know that the "patriarch" of Impressionism, Camille Pissarro, was quick to spot the young amateur's talent and zeal; his influence on Gauguin was direct and lasted more than ten years. "He was one of my teachers, and I do not disown him," wrote Gauguin shortly before he died. Although they probably first met in 1874, a closer relationship did not develop until 1878. Gradually, the collector was taken more seriously as an artist and was invited to participate in Impressionist exhibitions as early as the first part of 1879. He spent the summer at Pontoise at Pissarro's side. Gauguin's paintings of orchards and countryside smack of his teacher's, as do all of his landscapes until 1885.

The domesticity of *Mette Sewing,* one of Gauguin's best early paintings, reflects his peaceful life at the time.

Degas the Curmudgeon and Gauguin the Savage

Gauguin's interiors and human figures, however, point to his admiration of another artist, Edgar Degas, whom he probably met through Pissarro. Degas turned out to be one of Gauguin's staunchest supporters. As early as 1881 he not only persuaded the Impressionist dealer Durand-Ruel to buy Gauguin's work, but made purchases for his own collection. At one point Degas boasted ten Gauguins, including *La Belle Angèle, Woman with a Mango,* and *Hina Tefatu.* A respect and friendship blossomed between Gauguin, most of whose friends gave the ill-humored, ill-mannered artist a wide berth, and Degas, a notorious curmudgeon

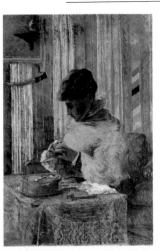

described by friends as "Degas the grumbler and Edgar the grouch." Degas' loyalty to Gauguin never wavered, and he continued to buy his work despite Gauguin's absence during the Tahitian periods; across the sea Gauguin continued to pay tribute to the other artist in both his writings and paintings.

These portraits of Gauguin and Pissarro were drawn in 1883 by teacher and pupil, respectively. Gauguin's linework lacks the energy and incisiveness of Pissarro's unaccommodating sketch of this young man who—somewhat impetuously, in the older artist's opinion—was about to make painting his career.

"He is naturally kind-hearted and he is intelligent," he wrote to Daniel de Monfreid from Tahiti. "In terms of both conduct and talent, Degas is a rare example of all that an artist should be.... No one has ever seen him or heard of his doing anything underhanded or tactless or mean-spirited. Art and dignity."

One of the first oils to make the critics stand up and take notice—J.-K. Huysmans hailed it as a model of naturalism in painting—was *Suzanne Sewing*, a nude reminiscent of Degas' handling of nudes. Degas again comes to mind when we see the off-center composition of *Interior, Rue Carcel*, a domestic scene set in Gauguin's apartment, with a large bouquet in the foreground, the artist partially seen behind a screen, and his wife glimpsed behind her piano. The influence of Degas' pictures of

"I do not hesitate to maintain that, among contemporary painters who have done nudes, none has yet struck so vehement a note of reality."
 J.-K. Huysmans, 1881, on *Suzanne Sewing*

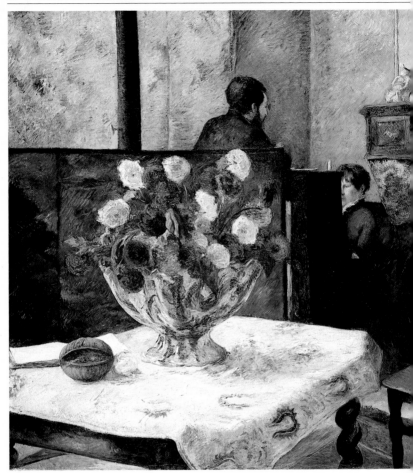

café singers on one of Gauguin's first wood sculptures, *The Singer*, is unmistakable.

"Secure a Place in Art"

When the Union Générale declared bankruptcy in 1882, the French stock market collapsed and many employees were laid off. Gauguin lost his job and began toying with the idea of painting for a living. Everyone was taken

In *Interior, Rue Carcel* we see Mette playing the piano while a man facing her (possibly the painter) watches and listens. Its daring composition was inspired by Degas.

aback at the prospect, including Pissarro, who felt responsible for Gauguin's enthusiasm. "He is moving away from Paris to give painting his all," he wrote to Eugène Mürer in November. "Through strenuous work he expects to secure a place in art.... He'll make good!" But when he discussed it with his son Lucien, Pissarro came closer to the mark: "[Gauguin] is more naive than I thought." Poor Mette was expecting another child; we can just imagine

This *Café Singer* is one of a series Degas exhibited in 1879.

what she thought. In November 1883 Paul, Mette, and their five children left Paris for Rouen, where "life is cheaper." The next two terrible years were to leave Gauguin with nowhere to turn, no alternatives save adventure and solitude.

His letters to his sidekick, Emile Schuffenecker, and to Pissarro indicate that he expected to succeed as quickly in

Carved and painted in 1890, this medallion of the singer Valérie Roumi attests to both the influence of Degas and the phenomenal talent of the budding sculptor.

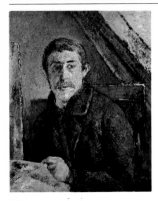

painting as he had on the Stock Exchange. "He is taking Rouen by storm," wrote Pissarro. Gauguin's confidence in his lucky star and in his genius was one of the invariables of his life, and, all things considered, destiny proved him right. But how many doubts, day in and day out, after irreversible decisions had been made! How much distress and posturing to prove to others how strong he was! Here, in that first departure to Rouen, was Gauguin in a nutshell: half-resolved, half-coerced. It was the same with his next departure, this time for Copenhagen, where he joined

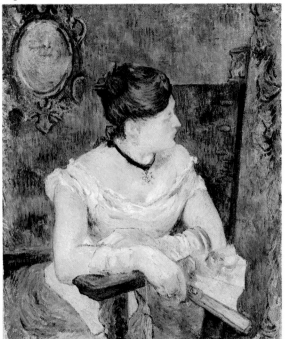

Copenhagen, 1885: Gauguin's first self-portrait (left) is set in a garret. Far right: A photograph of Paul and Mette from about the same time.

Eighteenth-century wooden tankard that once belonged to Gauguin (below).

This somewhat conventional image of *Mette Gauguin in an Evening Gown* is worlds away from the trying and tumultuous life she was soon forced to endure.

A still life (right) with rather mysterious proceedings (possibly a wake) in the background.

Mette (who had left Rouen with the children after six months). All but driven away by his wife's Danish relatives, he then left Copenhagen for Paris. The family would never be whole again, though he did not know it at the time. The fine Impressionist collection the young financier had put together was gradually sold off—except for the Cézannes, which Gauguin implored Mette to sell in only the direst straits.

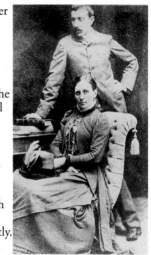

"What Holds Me Back Is Painting"

The period between 1883 and June 1885, which took Gauguin from Rouen to Paris by way of Copenhagen (where he was a sales representative for a canvas manufacturer), was a time of anguish mingled with self-assurance. His earliest self-portrait—the first of many—conveys this perfectly. Gauguin's letters from this period are bolder and

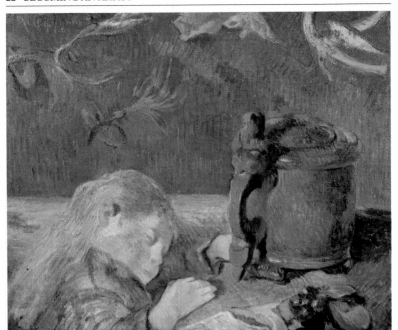

more intriguing than his paintings, although even back then his landscapes and portraits of children often contained remarkable things. For example, the *Sleeping Child* in front of a huge wooden tankard against a background that seems wallpapered with dreams is a study in unobliging but profound tenderness.

Gauguin's stay in Copenhagen was a financial, domestic, and artistic disaster. "Oh, my dear Pissarro," he wrote, "what a fix I've gotten myself into just now!" To Schuffenecker: "Sometimes I think I am going mad, and yet, the more I lie awake nights thinking things over, the more I think I'm right." "I have no courage, no money left," he wrote to Pissarro in May 1885. "Every day I ask myself if I oughtn't go to the attic and put a rope round my neck. The only thing that holds me back is painting." This startling—and undoubtedly sincere—statement sheds light on the driving force that was to keep Gauguin going to the

Contrasting views of family life: An affectionate painting of his sleeping child (above) and a caricature of a grimacing Gauguin and family "in the soup."

very end: that sense of a sacred duty that invested him with sacredness—and came to his rescue.

Paris 1886: A Hard Winter

By June he was back in Paris with his son Clovis, who had been left for a while in Gauguin's sister's care because Gauguin could not provide for him. Gauguin himself stayed with the faithful Schuffenecker, who had likewise cast off his moorings to the Stock Exchange, not for the bounding main, but to teach drawing in a school. This was a particularly bleak winter: His back to the wall, Gauguin was reduced to hanging posters to bring in a little money.

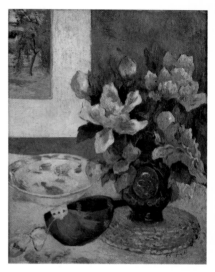

He painted very little but did get back in touch with the Impressionists and exhibited nineteen paintings in the eighth—and, as it turned out, last—Impressionist show, the one in which both Monet and Renoir refused to participate, the one in which Pissarro helped pave the way for Seurat's *La Grande Jatte* and works by other young Neo-Impressionists. The catalogue for the exhibition offers a telling commentary on this moment in Gauguin's life. For one thing, he was the only participant not to give a studio address (except for Mary Cassatt, but that was customary for a woman). For another, we can tell from the titles that his entries were painted the year before, many in the vicinity of Rouen or Copenhagen. Probably one of the best to come out of this trying year, *Still Life with Vase of Japanese Peonies and Mandolin*, gives us our first inkling of the future painter of tropical luxuriance.

Finally, around the middle of July, Mette received word that he had "scraped together the money for my trip to Brittany." Her husband was writing to her from Pont-Aven, the hamlet in Finistère that Gauguin was to make famous.

This still life reveals Gauguin's genius for color, and the choice of objects, his early penchant for the exotic. The mandolin is the one Gauguin himself played and later took to Tahiti. The painting on the wall—a Pissarro or Guillaumin from his own collection—has the white frame favored by Impressionists at the time.

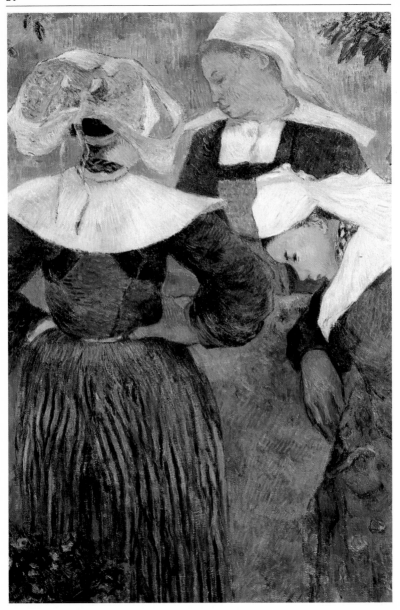

Jolted loose from his comfortable family life, impelled by circumstances, Gauguin went on to become an artist as if coerced by fate into making the tough choice of solitude. He was doomed to succeed, if only for his own sake. He needed to restore his wounded dignity, then command respect; to do that he needed most of all to work in peace. Gauguin had hardly lifted a brush for months. Starting in the summer of 1885, he longed to take refuge "in some out-of-the-way place in Brittany to paint pictures and live economically."

CHAPTER II

FIRST BRUSH WITH BRITTANY AND THE TROPICS

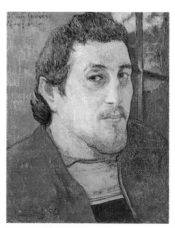

This self-portrait in a Breton outfit (1886), painted in Pont-Aven and dedicated to Charles Laval, was retouched later and given to another painter, Eugène Carrière. Left: Detail of *Breton Peasant Women*.

1886: The Gloanec Inn in Pont-Aven

In July 1886 Gauguin moved into the Pension Gloanec in Pont-Aven, a hamlet located near Quimperlé and a few kilometers from the sea. That in itself did not exactly make him a trailblazer. For some twenty years this village in Finistère had been known for welcoming artists, French and non-French alike—especially Americans— although no particularly revolutionary ones. An English

guide for artists visiting the region pointed out that "Pont-Aven has an advantage over other places in Brittany. Its inhabitants in their picturesque costume, which remains unaltered, have learned that to sit as an artist's model is a pleasant and lucrative profession."

For the first time in his life Gauguin devoted himself exclusively to painting, unburdened by professional or domestic cares—except for his concern about his family's future.

Work was the best balm; so was the strong impression he made on the artists' colony. "Now that I've been toughened by adversity," he wrote to Mette, "I think of nothing but work, my art. It's still the only thing that doesn't let me down. Thank God, I'm making headway every day.... At any rate, just now I take psychological satisfaction in ruling the roost here in Pont-Aven. All the artists fear me and like me: Not a single one resists my convictions."

Coming from so inexperienced a painter, Gauguin's statement—confirmed by firsthand accounts of his first Pont-Aven period—may strike us as the height of presumption, yet it was accurate.

Gauguin's commanding personality and artistic

ambitions predated his own revolution in painting, but others were already following his lead. "Tall [*sic*], dark-haired, and swarthy of skin, heavy of eyelid and with handsome features, all combined with a powerful figure," the English artist Archibald Hartrick later recalled. "In manner he was self-contained and confident, silent, and almost dour.... Most people were rather afraid of him."

This is corroborated by Puygaudeau, another artist who spent that summer at the Gloanec Inn. "His singular theories and even more singular paintings revolutionized

The Gloanec Inn was already popular among painters in the early 1880s. Here, the landlady, wearing a starched headdress, poses in front of her establishment with a large group of guests and staff. Gauguin was to be its only claim to fame.

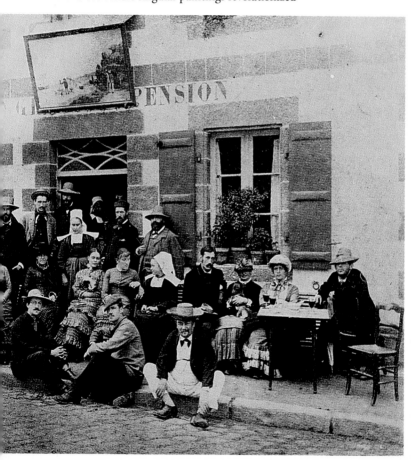

the entire artists' colony…. The younger ones sharply criticized him and readily held him up to ridicule, but they came under the influence of this man in spite of themselves."

B *reton Peasant Women* (1886).

Early Breton Paintings

Compared to other artists, Gauguin was a representative of the Parisian avant-garde, an "Impressionist," a word still fraught with heresy. The soft colors and divided brushwork of paintings like *Laundresses at Pont-Aven* show that at the time he was an exponent of an appealing, well-mannered Impressionism at that. Soon, however, he became more inventive. We clearly sense Gauguin's budding genius in *Breton Peasant Women*. His treatment of a picturesque subject is worlds away from similar scenes that Pascal Dagnan-Bouveret, an establishment artist, was painting nearby.

The composition of the picture is innovative. No longer just evocative details in a genre scene, the women's white

headdresses take on a purely decorative quality. There is something vaguely mysterious about their inscrutable arm movements and averted glances, while in their guileless expressions we see Gauguin's emerging predilection for faces that convey rough graciousness.

More startling in terms of both composition and subject matter is *Still Life with Profile of Laval.* Everything about this painting points to Gauguin's future. The model, a young painter Gauguin met in Pont-Aven, is the same Charles Laval who would soon accompany him on his first trip as a painter to an exotic destination. Already Gauguin's fruit look more like mangoes than apples. The curious pot that his friend seems to be scrutinizing through his pince-nez is an early specimen of Gauguin's astounding ceramics, which he started to produce just about this time (1886–7).

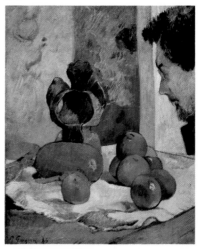

Gauguin the Ceramist

Shortly before leaving for Pont-Aven, Gauguin had been introduced to Ernest Chaplet, a friend of Félix Bracquemond's and a first-rate ceramist committed to reviving stoneware technique under the influence of Japanese ceramics. Gauguin may have done some work along these lines before he left Paris; but once he got back he threw himself into the new technique with a passion. Throughout the fall of 1886 and the following winter, he discovered a way of creating forms that were both innovative and traditional, a way of expressing—better than his painting could at the time—the primitive, elemental quality he was groping for. By year's end he was ready to contact Bracquemond. "If you are curious to see all the little

Still Life with Profile of Laval (1886). Gauguin and the younger painter were about to set out together for Martinique.

This unglazed stoneware vase with Breton-inspired decoration (winter 1886–7) recalls the piece of pottery in Gauguin's painting.

products of my wildest imagination come out of the oven, [they are ready]. You will certainly howl when you see these monstrosities, but I'm confident you'll find them interesting." Pottery enabled him to fashion objects that were both useful and artistic: "Beauty always finds its place," this pioneer of industrial design later wrote. "No quibbling," he exhorted manufacturers. "Get down to work and, above all, hire *artists*, not workers."

For Gauguin, these objects modeled by his own hand always struck a deeply personal and emotional chord. He was familiar with Peruvian ceramics; his mother had brought back a fine collection from Lima. Thus, pottery took him back not only to the beginnings of art, but to his own childhood. Forever in search of money, he also hoped that his ceramics would sell better than his paintings. In any event, they were quickly exhibited and evaluated, particularly in articles by Félix Fénéon, the critic who also "discovered" Seurat and Rimbaud around this time. But few articulated their thoughts about the technique of ceramics as well as Gauguin himself. "Making ceramics is not an idle pursuit," he wrote. "Ages and ages ago this art was continually in favor among the American Indians. God created man with a little mud. With a little mud you can make metal and precious stones—a little mud and a

Anthropomorphic Peruvian pottery, like the piece shown at left, made a lasting impression on Gauguin.

A little shepherdess in Pont-Aven attire (below) graces one of the long sides of a polychrome stoneware jardiniere (1886–7).

little genius!" He added this brilliant remark: "A fired substance takes on…the character of the oven and thus becomes more somber, more serious as it sustains the hellish heat."

Fleeing Paris to Live Like a Savage

"What I want most of all is to flee Paris, which is a wilderness for a poor man. My reputation as an artist is growing day by day, but meanwhile I sometimes go three days without eating, which undermines not only my health but my *energy*. This I intend to restore, and I am off to Panama to live like a *savage*. I know of a little island in the Pacific, Taboga, a league off the coast of Panama. It is almost uninhabited, open, and very fertile" (to Mette, late March 1887).

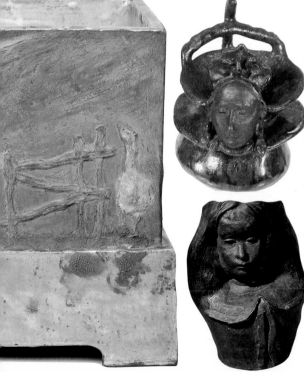

Two portrait vases. The lower one, a sensitive portrait of Jeanne Schuffenecker, the daughter of Gauguin's friend, exemplifies the artist's own statement: "In ceramics, line and sculpture alike must be tailored to the medium."Gauguin's pottery prompted a strong and immediate reaction from his contemporaries, one of whom described them as "strange and savage ceramic pieces into which the sublime potter has worked more soul than clay."

This quest for paradise was to end in forced labor. He left in April with Charles Laval. In Panama they had hopes—misplaced, as it turned out—of getting some help from his brother-in-law, Juan Uribe, and soon he was out of money and forced to work as a laborer on the Panama Canal, where workers and foremen were in demand at the time. After various mishaps, including bouts with malaria and dysentery, the two friends moved to Martinique, which they had admired in passing on their journey west. By June Gauguin was ready to paint. "We have found a native hut on a plantation, two kilometers from town," he wrote to Schuffenecker in July 1887. "Below us, the sea and a sandy beach for bathing, and on either side coconut palms and other fruit trees for a landscape painter to feast his eyes on."

Although this stint had an unhappy ending—Gauguin took sick and had himself repatriated in November—it yielded his first superb exotic landscapes and marked a break with the Impressionism of Pissarro. He had truly come of age. Still using fine, close brushstrokes, he nevertheless conveyed his sense of wonder by means of sumptuous, muted combinations of close colors—a hallmark of his painting from then on. Moreover, the composition of certain scenes with human figures is a reminder of Gauguin's interest in Japanese prints. "What appeals to me most is the people, and every day brings a ceaseless coming and going of island women in colorful faded finery, with their infinite variety of graceful movements."

The Martinique period was more than just a trial run for the Tahitian paradise, and when Gauguin got back Paris took note of his achievement. As Octave Mirbeau wrote soon thereafter, "There is an almost religious mystery, a sacred, Eden-like abundance in these forest interiors with their monstrous vegetation and flowers, their hieratic figures, and their tremendous sunsets."

Gauguin the painter's first encounter with the tropics took place in 1887 on the island of Martinique. When he returned to Paris the following winter his lush landscapes (*Tropical Vegetation*, left) were much admired by critics like Félix Fénéon, dealers like Theo van Gogh, and painters like Theo's brother Vincent.

Martinique Women (detail), a drawing for the painting *Picking Mangoes*, which Theo van Gogh bought for his own collection.

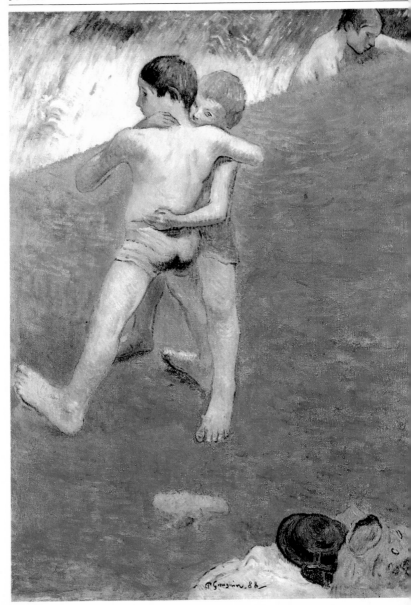

New Acquaintances

During a brief stay in Paris (winter of 1887–8), Gauguin sold his first works of art and made new friends destined to play a decisive role in his life. One was Daniel de Monfreid, who during Gauguin's sojourns in the South Seas took over Schuffenecker's duties as trusted correspondent. Then there were the van Goghs: Vincent, the painter, who had been in Paris for a year, and his younger brother, Theo, a dealer intent on promoting avant-garde art at the famous Boussod and Valadon Gallery. Theo bought some pottery and several paintings, including a large oil from Martinique, *Picking Mangoes* (Rijksmuseum Vincent van Gogh, Amsterdam). Now Gauguin had enough money to return to Brittany for an extended period, from late January to late October 1888. In terms of originality, intense productivity, and the decisive influence it was to have on an entire generation, this stay was to prove perhaps the most pivotal of his entire development.

Gauguin, sporting a Breton vest, between his eldest children, Emil and Aline.

"I Hear the Muffled Tone..."

In the summer of 1886 Brittany had provided Gauguin with a convenient haven. This time it took on the aura of myth. He now understood that Brittany had more to offer than subjects and a livelihood. It brought him that much closer to the wellspring he had been seeing for the past several years, the one that would enable him to express something that was his and his alone. The previous year he had managed to win over younger artists with his ideas and talent. Yet he had done nothing more than voice ideas

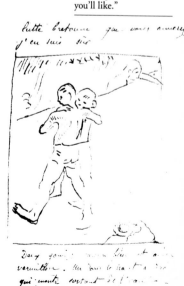

Children Wrestling (left, July 1888), which the artist described in a letter to Vincent van Gogh (below): "I've just finished a Breton wrestling scene I'm sure you'll like."

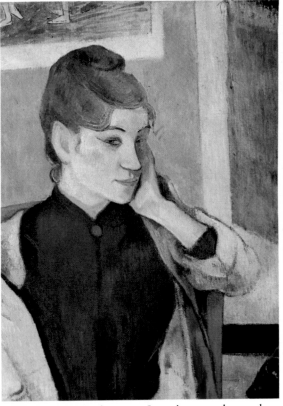

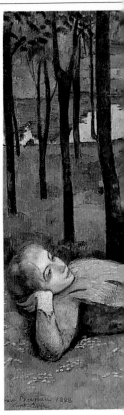

already in the air—they were Seurat's, too—about color harmony, the technique of contrasts (which he did not apply in his own painting at the time), the need to simplify, and the synthesis of sensations the artist was supposed to bring about.

These months in 1888 were to witness a true change. Why? To be sure, the sudden maturation of an artist is mysterious. But we sense, for one thing, that the simplification and boldness Gauguin had introduced into his pottery now carried over into his painting and, for another, that Martinique gave him a clearer idea of his objective, which can be roughly described as a "new primitivism." He made all this known to Mette when he

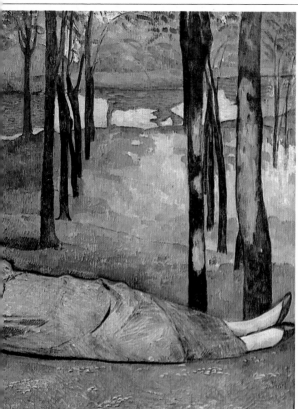

Gauguin's portrait of Emile Bernard's younger sister, Madeleine (far left), who exerted considerable influence on Gauguin during the summer of 1888 at Pont-Aven. He was smitten with this spirited, independent teenager who, much to his dismay, was to fall in love with Charles Laval, his pupil and traveling companion in Martinique.

That summer Emile Bernard painted *Madeleine in the Bois d'Amour* at Pont-Aven. "My sister was very beautiful and very mystical…. Neither Gauguin nor I attempted anything more than a caricature [of her], on account of the ideas we had at the time about *character*." Gauguin offered her advice in illuminating letters that reveal his views on women. This attractive young woman had a brief and tragic life. She died of tuberculosis at the age of twenty-four, a year after the same disease had claimed the life of her fiancé, Charles Laval.

left Paris. "I am going to work seven or eight months straight, steeped in the character of the people and the region they live in, an absolute prerequisite for good painting." A letter he wrote to Schuffenecker from Pont-Aven early in March 1888 says it all: "I love Brittany. There is something wild and primitive about it. When my wooden clogs strike this granite ground, I hear the dull, muffled, powerful tone I seek in my painting."

Which Brittany?

Starting with the Romantic era, no region in France was believed to be more resistant to modernism and new ideas than Brittany. For some it was the epitome of

backwardness; for others, a precious repository of Celtic
religious traditions, a land of legend which Cornélis
Renan had already extolled as a "primitive world [where]
Paganism lurked behind the veneer of Christianity."
The literati of the day were intrigued by Brittany.
In 1886 Maurice Barrès, then the Young Turk of the
literary avant-garde, summed up his impressions of his
travels through the region: "Here, at last, the Gallic
rooster is not tarnished by Roman dust." In their recently
published *Voyage en Bretagne* Flaubert and Maxime du
Camp wrote that they had found in Brittany "the human
form in its pristine freedom, as on the first day of
Creation." For Gauguin, therefore, whereas the fine arts
were the embodiment of Greece and Rome, Brittany
represented something inherently pre-academic, a return
to origins. No more was he just another Impressionist
working from nature, as he had been in 1886; now he
was intent on capturing the "soul" of the region, the
immemorial character of its scenery and inhabitants.
The advice he gave Schuffenecker sums up the enormous
step he had taken away from Impressionism: "Don't copy
nature too literally. Art is an abstraction. Derive it from
nature as you dream in nature's presence, and think more
about the act of creation than the outcome."

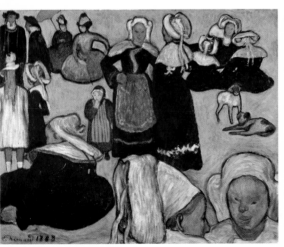

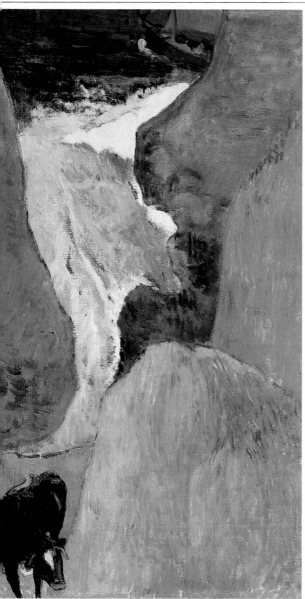

Emile Bernard painted *Breton Women in a Meadow* in the summer of 1888 (far left). The simplified mass and space, heavy outlines, and expanses of pure, unmodulated color point to ways in which the younger artist's stylistic boldness may have influenced Gauguin.

Gauguin's debt to Japanese prints is apparent in *Seascape with Cow on the Edge of a Cliff* (left), in which a bird's-eye view and sweeping expanses of flat color create an abstract pattern of interlocking forms.

Gauguin and Chaplet collaborated on this vase decorated with Breton scenes, below.

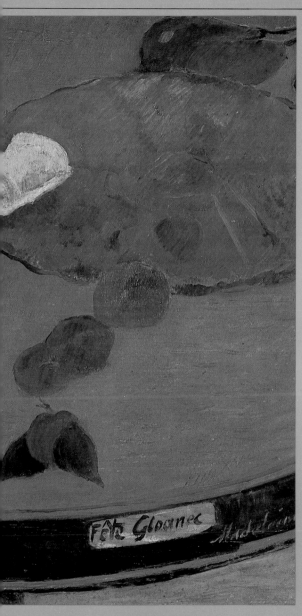

Fête Gloanec

The Work of a Novice?

Marie-Jeanne Gloanec ran the boardinghouse where Gauguin took his meals while in Pont-Aven. In August 1888 he offered her this still life in honor of her name day. According to painter Maurice Denis, who once owned *Still Life: Fête Gloanec*, Mme. Gloanec cared so little for the boldly colored and simplified new style that "to get [her] to accept the painting, Gauguin signed it 'Madeleine B.' and declared that it was the work of a novice."

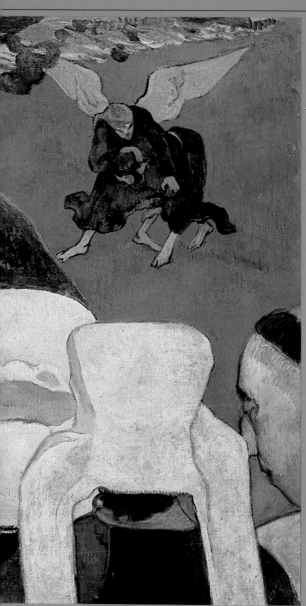

Symbolism in Painting

Painted in late summer 1888, *The Vision After the Sermon*, or *Jacob Wrestling with the Angel*, subsequently became the pictorial manifesto of Synthetism, the style of vivid colors and simplification that Gauguin and his young friends pioneered at Pont-Aven. In a lengthy article on the painting, critic Albert Aurier anointed Gauguin the dean of Symbolism in painting.

"I think I have achieved a great rustic and super-stitious simplicity in the figures. The overall effect is very severe. For me in this painting, the land-scape and the fight exist only in the imagination of the people at prayer after a sermon. That is why there is a contrast between the people, who are natural, and the struggle going on in a landscape which is not natural and out of proportion."

To Vincent van Gogh,
Pont-Aven, 1888

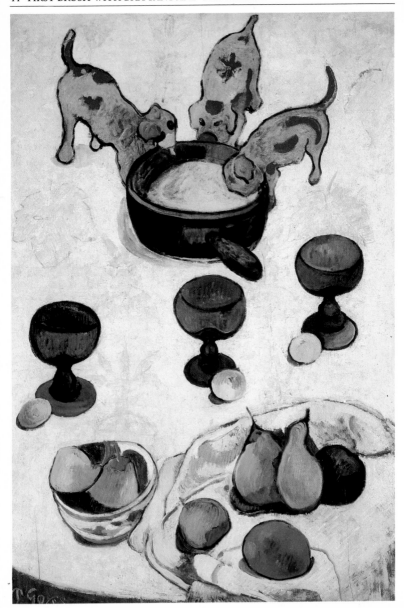

"Thoroughly Japanese by a Savage from Peru"

This time Gauguin backed up his theorizing with truly innovative work. These six months in Brittany were intensely productive, if only in quantity: seventy-five known paintings in 1888, compared with only twenty-four the previous year. As for their quality, witness *Children Wrestling*, in which space is handled in a totally new, nonrepresentational way, in which shapes and colors embody the simplification and synthesis he professed to seek. Fully aware that the austerity of Japanese prints had left its mark on him, he described the picture as "thoroughly Japanese by a savage from Peru."

Gauguin's first "Japanizing" masterpiece was *The Vision After the Sermon*, in which a drawing of wrestlers by Hokusai was the basis for his interpretation of the theme of Jacob wrestling with the angel. Here is our first glimpse of Gauguin the uninhibited yet refined colorist. He looked upon this painting as a challenge: "This year I have sacrificed everything—execution, color—for style, because I wished to force myself into doing something other than what I know how to do." Surely it came as no surprise that the widening gap between himself and surface reality did not sit well with his former Impressionist friends, Pissarro in particular.

But Gauguin knew where he was going, and he was too instinctively a painter not to sense the dangers of a purely conceptual approach. "Clearly the path of Symbolism is full of perils," he wrote to Schuffenecker on 16 October 1888, "but it is fundamental to my nature.... I am well aware that I shall be understood *less and less*." He concluded, "You know full well that where art is concerned I am always basically right!"

We know that in August 1888, when *Still Life with Three Puppies* (left) was painted, Gauguin talked of "painting like children" (letter from Vincent van Gogh to his brother). The subject proper—three puppies, three cups—indeed reminds one of a counting rhyme. Of greater significance, however, is the elementary, seemingly awkward style, which reflects a conscious attempt at primitive naiveté. Hokusai's drawing of puppies (below) exemplifies those aspects of Japanese prints that appealed to Gauguin: objects arranged on the picture plane, bird's-eye view, absence of perspective.

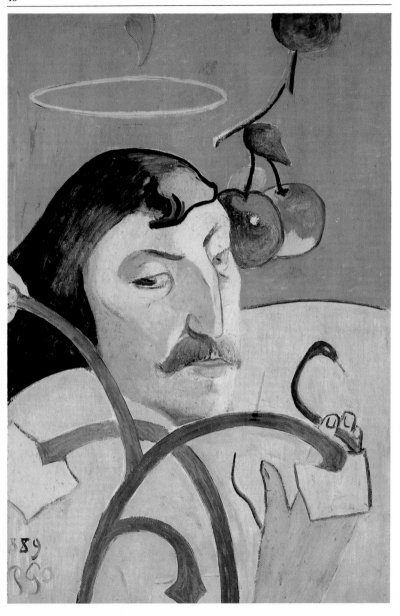

Theo van Gogh was the first dealer to show genuine interest in Gauguin, to believe in his genius. Thanks to him, the artist had the wherewithal to paint undisturbed during that phenomenal year of 1888. Theo was the one to whom Gauguin sent the innovative—and, before long, controversial—work he started to turn out. He had met Vincent on his return from Martinique, but at the time the painter was, as far as he was concerned, just his dealer's brother.

CHAPTER III
THE INDIAN AND THE SENSITIVE MAN

Gauguin once described himself in a letter to Mette: "You must remember that there are two temperaments within me, the Indian and the sensitive man." The artist and aloof hero coexisted with the husband and family man. In late 1889 he portrayed himself as a haloed saint (far left), or perhaps a magus and initiate holding a snake, symbol of divination. At left is the cover of the *Volpini Suite*, a set of lithographic drawings.

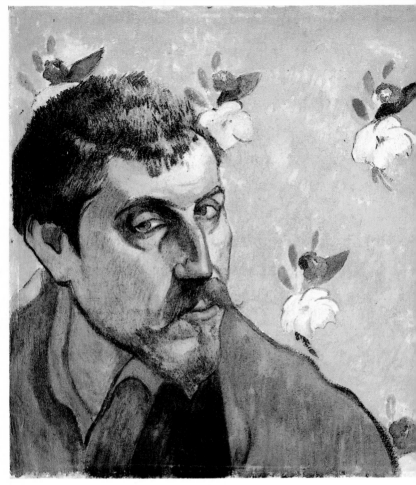

Back in November 1887 Gauguin had taken part in a show Vincent organized at Le Tambourin, a Montmartre restaurant. The two artists hit it off and exchanged paintings. Gauguin selected one of van Gogh's early still lifes of sunflowers; Vincent took a Breton landscape in return.

The famous, explosive, disaster-ridden friendship between these heroes of modern painting was originally a

Les Misérables, self-portrait of Gauguin dedicated "to my friend Vincent [van Gogh]," with a profile of their mutual friend, the young painter Emile Bernard, at the upper right.

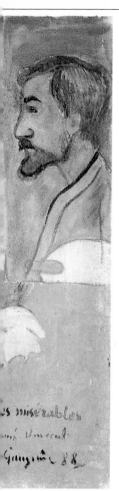

complex four-way relationship that also involved Theo and Emile Bernard, Vincent's precociously gifted friend. Although Bernard had already met Gauguin in the summer of 1886, he did not play a key role in the painter's life until two summers later. Afterward, Bernard complained his whole life long that Gauguin had usurped from him the invention of Synthetism and Cloisonnism. Clearly, in 1887, when Gauguin was still an Impressionist, Bernard was already painting with broad, sharply defined, strongly outlined areas of bright color. And if Bernard's *Breton Women in a Meadow* indeed predates *The Vision after the Sermon*, there can be no denying the influence the youngster had on Gauguin. But what difference does it make? Whatever the more famous of the two got out of it obviously proved more innovative and momentous. Besides, every great artist absorbs whatever he feels can move him forward. The debate serves no useful purpose, nor does it detract from either of them—even if Gauguin managed to profit by the inspired ideas of an unseasoned painter emboldened from the first by the inexperience of youth.

Theo van Gogh, Vincent's brother, moral supporter, and financial mainstay, was in charge of contemporary art at the famous Boussod and Valadon gallery.

"To My Friend Vincent": A Self-Portrait as Jean Valjean

Vincent van Gogh spent the summer of 1888 alone in Arles and envious of the Breton community; he longed to get his friends to gravitate toward him. He asked for their portraits, and he sent them his. The one he received from Gauguin was entitled *Les Misérables* and dedicated

"The girlish background with its childlike flowers is there to bear witness to our artistic purity. As for this Jean Valjean [hero of Hugo's *Les Misérables*, hence the painting's title] whom society has oppressed, whose love and strength have turned into an outlaw—does he not also represent today's Impressionist? And by painting him with my own features, you have, in addition to a likeness of myself, a portrait of us all, wretched victims of society."

Letter to van Gogh, October 1888

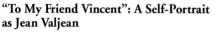

"to my friend Vincent." Gauguin himself commented upon it at length. "I feel compelled to explain what I tried to do. It is the face of an outlaw, ill-clad and powerful like Jean Valjean, with an inner nobility and gentleness. The face is flushed, the eyes enveloped in the colors of a furnace fire. This is to represent the volcanic flames that set the artist's soul ablaze. The line of the eyes and nose, reminiscent of flowers in a Persian carpet, epitomizes an abstract, symbolic art."

This engrossing formal analysis indicates the course Gauguin was setting for himself as he moved farther away from Impressionistic realism. A few weeks earlier he had written to Vincent that he did not feel "capable" of painting a portrait "since what you want is not a mere facial replica.… In any case it will be an abstraction."

What presence just the same! To be sure, there was a measure of posturing in Gauguin's wish to portray himself as a martyr, as a romantic hero like the outlaw in Hugo's *Les Misérables*. But this portrait clearly reflects both an awareness of his new stature and the irreversible split with his family and former life.

Spurned by his wife—a recurring theme in all of his letters to Mette—he was far more distressed by this rift than we can imagine. Appearances to the contrary notwithstanding, Gauguin was a very affectionate father and missed his children a great deal. His various personal setbacks only strengthened the hold of the calling that was vital to him from then on. He was doomed to genius, to solitude, to perpetually moving on as a means of escape. A letter to Mette neatly illustrates how he managed to turn his weakness into strength and came to regard painting as his reason for living. "Ever since I left, I have gradually hardened this sensitive heart of mine in order to keep up my psychological fortitude. All that part of me lies dormant; so it would be dangerous for me to have my children by my side, only to go away afterward. You must remember that there are two temperaments within me, the Indian and the sensitive man. The latter has disappeared, which allows the Indian to proceed straight ahead without wavering" (February 1888).

Two versions of the same scene painted from life in the Poets' Garden at Arles. Gauguin's *Old Women of Arles* (above) was probably inspired by van Gogh's oil (far right), not the other way around, as was once thought.

Two Months in Arles

Prodded by Theo van Gogh, who offered to buy his work if he went to live with Vincent, Gauguin halfheartedly left Pont-Aven for Arles. He arrived on 23 October: So began a famous two-month stay that Gauguin himself later chronicled. A few indisputable facts can be sifted from this well-documented period. One is that competition and the exchange of

ideas made living together extremely fruitful for both painters. Another is that their friendship, although stormy, was very real. Self-centered, domineering, accustomed to throwing his weight around, Gauguin must have wearied of Vincent's morbid mood swings, his need for interminable, occasionally heated, and even hysterical discussions about aesthetic and moral issues. Moreover, mingled with Gauguin's affection was the fact that it was to his advantage to help his dealer's brother. Vincent was greatly impressed ("without the slightest doubt we are in the presence of an unspoiled being with savage instincts"), but won over more by Gauguin's force of character than by his intelligence. Probably irritated by his companion's sometimes muddled Symbolist ambitions, he nevertheless admired Gauguin the artist, especially the one who painted "tropical nature" (at the time still limited to Martinique). Finally—and we can better gauge this since the recent publication of correspondence between Gauguin and the brothers van Gogh—their affection withstood Vincent's fits of madness and the notorious episode of the severed ear. They corresponded regularly until Vincent's suicide at Auvers in 1890. "I owe a great deal to Theo and Vincent," Gauguin wrote at the end of his stay in Arles. "Although we've had our differences, I cannot be cross with a kind-hearted fellow who is ill, is suffering, and asks for me."

Gauguin's letters intimate that living together in the now-destroyed "little yellow house" in Arles must not have been easy. "I am quite out of my element here in Arles," he wrote to Emile Bernard. "I find everything—the scenery, the people—so petty, so shabby. Vincent and I don't see eye to eye on

things in general and painting in particular. He admires Daumier, Daubigny, Ziem, and the great Théodore Rousseau, all people I cannot abide. He on the other hand hates Ingres, Raphael, and Degas, all of whom I admire.... He likes my paintings very much, but while I'm working on them he is forever saying that this is wrong or that is wrong." He concluded, "He is romantic, while I lean more toward the primitive." Yet, we cannot help thinking about the Bretons and, later on, the Tahitians Gauguin painted when we read Vincent's statement to his brother about "painting men and women with that vaguely eternal quality once symbolized by a halo and which we try to capture with the very radiance and resonance of our colors."

In the Café (November 1888) depicts the interior of the Café de la Gare on the Place Lamartine in Arles. Its proprietors, Monsieur and Madame Ginoux, frequently posed for van Gogh: Mme. Ginoux was the model for his famous *L'Arlésienne*.

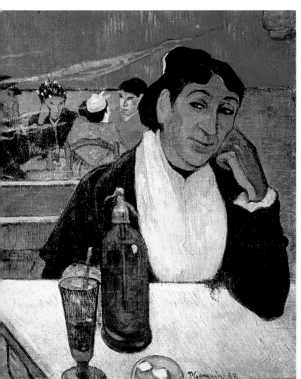

"I have also done a café [scene] which Vincent likes very much and myself rather less. Basically it's not my kind of subject, and the vulgar local color doesn't suit me. I like it well enough in other people's work but am apprehensive about it in my own.... Above, red wallpaper and three whores, one with her hair full of curl-papers.... In the foreground, a fairly well finished figure of an Arlésienne.... A streak of blue smoke runs across the picture, but the figure in front is far too conventional."

To Emile Bernard, from the letter shown at far left

Vincent Through Gauguin's Eyes

"I hit upon the idea of painting his portrait while he was at work on the still life he loved, the one with sunflowers. When I finished the portrait he said to me, 'That's me all right, but me gone mad.'"

Avant et Après

L ater, Vincent commented further on this painting in a letter to Theo: "It's me all right, but me as I was back then—extremely tired and charged with electricity" (10 September 1889). The sunflowers next to the easel are on the cane-seated chair van Gogh later painted empty, except for a candlestick, and entitled *Gauguin's Chair* to symbolize his absence. The bird's-eye view and off-center composition create a feeling of tension and a caving in that make this as much a psycho-logical portrait as a physical one.

Breton Women in Arles

In *Grape Gathering: Human Misery*, Gauguin positioned the woman in the foreground like a Peruvian mummy (below) to convey her weariness and dejection.

"Purple vines forming triangles against an upper area of chrome yellow. On the left, a Breton woman of Le Pouldu in black with a gray apron. Two Breton women bending over in light blue-green dresses with black bodices.... It's a study of some vineyards I saw at Arles. I've put some Breton women in it—accuracy doesn't matter! It's the best oil I've done this year."

To Emile Bernard

1889–1890: Primitivism at Le Pouldu

Gauguin was coming to realize that he had been filtering the individuality that lay at the core of his art through what he perceived to be his deficiencies, his lack of technical training, his "wildness." From now on, he knew who he was and where he was going. There would be no more prolonged stays in Pont-Aven, which he felt had become too touristy. In October 1889 he decided to move to Le Pouldu. This little seaside fishing village was to become the second Breton shrine in the history of painting, and Marie Henry's inn, the hub of a new artists' retreat. Here Gauguin was surrounded by painters who rather thought of themselves as his disciples: Meyer de Haan, Emile Bernard (with whom he soon had a falling out), Paul Sérusier, Charles Filiger, Armand Séguin. In a few short months he turned out a string of masterpieces, each one freer, bolder in color, and more imaginative than the last, but always rooted in the real Brittany as Gauguin perceived it—coarse, elemental, primitive.

Two examples of this Breton Primitivism or Synthetism are *The Yellow Christ* and *La Belle Angèle*. The first was probably begun in Pont-Aven, since it depicts a polychrome wooden crucifix that still graces the chapel at Trémalo, not far from Pont-Aven. In a blend of the real and the imaginary, the picture sets the Trémalo Christ against a yellow-and-red background landscape and transforms the Three Marys of Calvary into Breton women wearing headdresses. The vivid colors, absence of shading, and outlining of forms with a fine blue line

The source for *The Yellow Christ* (autumn 1889, below) is a carved polychrome crucifix in the church at Trémalo, near Pont-Aven. As in *The Vision After the Sermon* Gauguin incorporated the Breton women he saw every day into a biblical scene. Left: A photograph of Gauguin in the Breton outfit he sported at Pont-Aven.

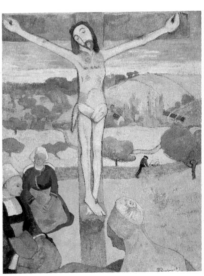

exemplify Cloisonnism, a style borrowed from stained glass, enamelwork, and certain kinds of pottery. Some critics went into raptures over the painting, and soon afterward Octave Mirbeau wrote of Gauguin's "unsettling, savory mingling of barbaric splendor, Catholic liturgy, Hindu reverie, Gothic imagery, and obscure, subtle symbolism" (February 1891).

In *La Belle Angèle*, whose drowsy expression Theo van Gogh likened to that of "a heifer… so fresh and countrified," Gauguin implies a parallel between the primitivism of the sitter and that of the Peruvian ceramic placed beside her. The device of setting a portrait inside a circle was inspired by popular Japanese prints of actors.

Self-portrait of Gauguin (1889–90) in front of two recent works: *The Yellow Christ* (a mirror image, hence, reversed) and a piece of pottery, also in the form of a self-portrait. He offered the tobacco jar to Madeleine Bernard—who turned it down —with a letter explaining that "it looks vaguely like the head of Gauguin the savage."

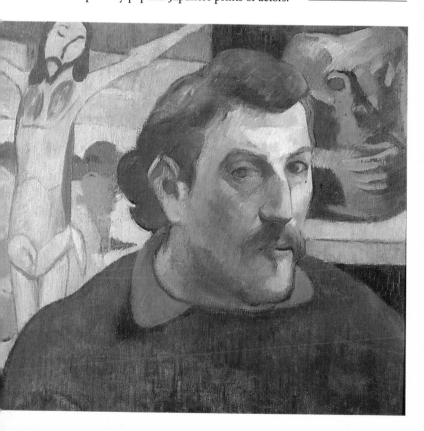

In certain nudes, such as *In the Waves (Ondine)*, Gauguin combined Japanese-inspired flattened perspective with the rugged innocence of the subject's body and face. The result is one of his earliest mythic images of primitive ingenuousness, which, although elaborated in Tahiti, first surfaced in Finistère.

1889: The Paris World's Fair

In three years Gauguin had made his presence felt, at least among the avant-garde. His talent, indeed his genius, now compelled recognition. Moreover, he had found a dealer and some buyers and had befriended a number of artists and writers who admired and encouraged him. He had not shown a group of paintings since the last Impressionist exhibition in 1886. In 1889, however, his work went on public display twice. In February he exhibited twelve pictures in Brussels with Les XX (so named because originally there were twenty participating artists), one of the most dazzling showcases for avant-garde art Europe had ever witnessed. Even more works by Gauguin could be seen at the Impressionist and Synthetist exhibition that Schuffenecker and he arranged at Volpini's Café des Arts on the grounds of the 1889 Paris World's Fair.

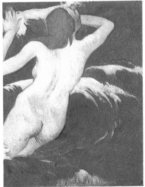

Largely unnoticed by the general public, this show was a milestone in the history of modern painting. Here the young painters of the next generation— Bonnard, Denis, Vuillard— got a closer look at the new style they had first glimpsed

in *The Talisman*, a panel painting Sérusier (the *massier*, or student-in-charge, at the Académie Julian) had done

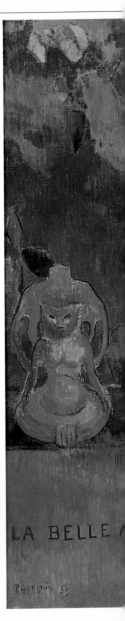

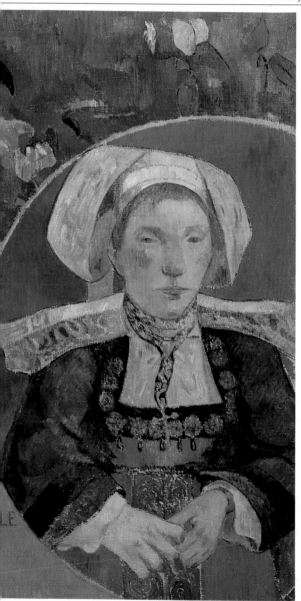

Gauguin often reprised the same theme in different mediums. Far left, above: *In the Waves (Ondine)*, an oil painting from the spring of 1889, may have been inspired by Degas' pictures of nude women at their toilet, which Gauguin had recently seen at a Paris exhibition, but the wave motif and broad expanses of flat color derive from Japanese prints. The painted relief carving *Be Mysterious* below it both echoes this scene and prefigures the Tahitian nudes.

Turned down by its own model, this portrait of Marie-Angélique Satre (*La Belle Angèle*) was bought by Degas at the public auction Gauguin held at the Hôtel Drouot in 1891 to raise money for his trip to Tahiti. When Theo van Gogh received the painting, he mentioned it to Vincent: "It's a very fine picture arranged on the canvas like...Japanese prints....The woman looks a little like a heifer, but there is something so fresh and so countrified about it that it is very pleasant to behold."

in Pont-Aven under Gauguin's supervision. Gauguin's innovations were a revelation to the young writers who soon took up his cause, particularly Charles Morice and Albert Aurier, a poet who championed Gauguin until his untimely death in 1893.

The World's Fair must have thrilled Gauguin. To begin with, he spoke out vociferously during the controversy sparked by the then brand-new Eiffel Tower. In an article on art at the World's Fair he wrote glowingly about the "triumph of iron" and "Gothic tracery in iron" and called for a new breed of engineer-architect willing to strip basic building materials of their overlay of decorative stuccowork and gilding.

In the summer of 1888, under Gauguin's supervision, Paul Sérusier painted *The Bois d'Amour* using pure colors without any shading.

His quest for authenticity led him to other attractions at the World's Fair. He was fascinated by the colonial pavilions, with their diverse specimens of dwellings and demonstrations of exotic folkways. He pored over reproductions from the temples of Angkor Wat and Borobudur and watched female dancers perform at the Javanese pavilion. No sooner had he returned to Le Pouldu than he began confiding his plans for the coming winter to Emile Bernard. "If I can get some job or other in Tonkin, I'll run off to study the Annamites. Terrible itching for the unknown that makes me do things I shouldn't."

GROUPE IMPRESSIONNISTE ET SYNTHÉTISTE
CAFÉ DES ARTS
VOLPINI, Directeur
EXPOSITION UNIVERSELLE
Champ-de-Mars, en face le Pavillon de la Presse
EXPOSITION DE PEINTURES
DE

Paul Gauguin Émile Schuffenecker Émile Bernard
Charles Laval Louis Anquetin Louis Roy
Léon Fauche Daniel Nemo

This painted wood panel was renamed *The Talisman* by the group of artists later known as the Nabis, whose interest in Gauguin and his friends turned to enthusiasm when they saw their work at the Café Volpini exhibition.

"A Great Rebirth of Painting Awaits Us There"

Soon he was leaning more toward Madagascar, which he had learned about through Odilon Redon's wife. "I will found the Studio of the Tropics. Anyone who wishes to visit me there may do so," he wrote to Bernard. Then, going into greater detail, he hoped to have enough money

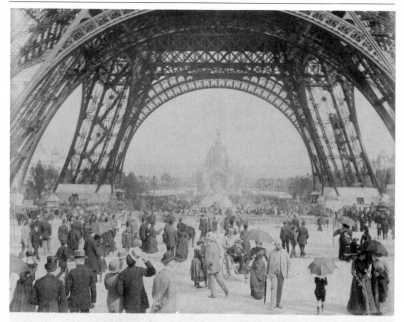

EXPOSITION UNIVERSELLE DE 1889
Au pied de la Tour Eiffel.

"to buy a native hut like the ones you saw at the World's Fair.... Women down there are, so to speak, obligatory, which will provide me with models every day." Fueling Gauguin's already burning desire to get away was the prospect of starting up the kind of artists' cooperative van Gogh had envisioned. Indeed, Vincent may have had a hand in Gauguin's decision to go to Tahiti. The pictures from Martinique brought to life the island Vincent had only read about in books by Pierre Loti. "What Gauguin tells me about the tropics seems wonderful," wrote van Gogh. "Surely a great rebirth of painting awaits us there." Who knows? Perhaps the memory of Vincent's enthusiasm helped keep this hope alive.

The 1889 World's Fair was a showcase for gigantic iron structures like the Galerie des Machines (demolished) and the Eiffel Tower. Above: The base of the newly opened tower. Left: Dancers performing at the Javanese pavilion.

Gauguin was intent on leaving behind a West made "rotten" by industrial civilization. "Even a [man with the strength of] Hercules can, like Antaeus, gain new vigor just by touching the ground [of the Orient]. A year or two later you come back robust...."

But he was no longer talking in terms of a year or two when he wrote to Odilon Redon in September 1890. "Madagascar is still too close to the civilized world. I will go to Tahiti and I hope to finish out my life there. I believe that my art, which you love, is but a seed and in Tahiti I hope to cultivate it for myself in its primitive and savage state."

At the request of Charles Morice, Octave Mirbeau wrote articles in *L'Echo de Paris* and *Le Figaro* about the forthcoming public auction of Gauguin's pictures at the Hôtel Drouot (February 1891). The proceeds from the sale made it possible for him to plan his departure. After a brief visit with his family in Copenhagen, he finally set out for Marseilles on April 1.

A few days earlier his friends gathered at a banquet to bid him farewell. Stéphane Mallarmé rose and proposed a toast: "Gentlemen, the most urgent matter before us is to drink to the return of Paul Gauguin, but not without admiring that superb conscience of his which, in the brilliance of his talent, leads him to seek exile in faraway places and renewal within himself."

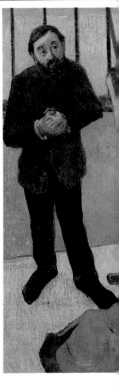

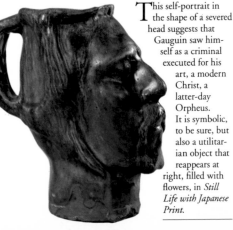

This self-portrait in the shape of a severed head suggests that Gauguin saw himself as a criminal executed for his art, a modern Christ, a latter-day Orpheus. It is symbolic, to be sure, but also a utilitarian object that reappears at right, filled with flowers, in *Still Life with Japanese Print*.

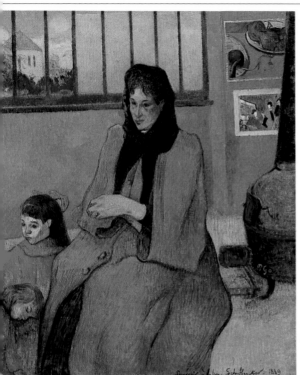

A sarcastic family portrait of the Schuffeneckers, with whom Gauguin stayed in Paris in 1889.

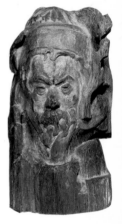

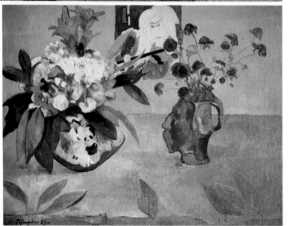

An intentionally rough and primitive wooden bust of Meyer de Haan—friend, pupil, and fellow boarder at Marie Henry's inn.

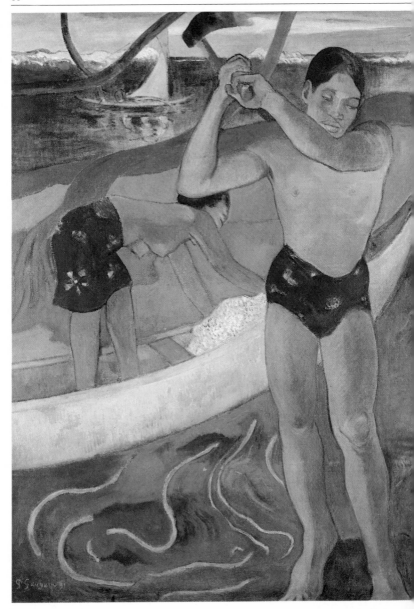

"I am leaving to be at peace, to rid myself of the influence of civilization. I only want to create art that is simple, very simple. To do that I need to renew myself in unspoiled nature, to see nothing but savages, to live as they do, with no other concern but to convey, as a child might, what my mind conceives, abetted only by primitive means of expression, the only right and true ones there are."

From an interview with Jules Huret,
L'Echo de Paris, 1891

CHAPTER IV
IA ORANA TAHITI

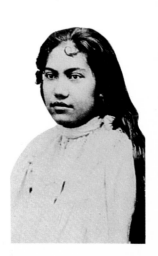

Painted shortly after Gauguin's arrival, *Man with an Ax* captures in a characteristic scene the simplicity and tranquility of daily life in Tahiti. Right: Tehamana, the *vahiné* with whom Gauguin shared these two years.

Gauguin did not reach Papeete until 9 June 1891, after traveling more than two months. The islanders were taken aback at this painter who had come on an "artistic mission." Lt. Jénot, who was stationed there at the time, left an eyewitness account of his arrival: "It should be stated right away that as soon as Gauguin landed he drew catcalls and looks of astonishment from the natives, especially the women. He had a tall [sic], straight, powerful build and maintained an air of profound disdain despite his already awakened curiosity and, no doubt, anxiety about his future work.... But the thing that especially held everybody's attention was his long salt-and-pepper hair, which fell to his shoulders from beneath a broad-brimmed brown felt cowboy hat." He did not paint much at first. "I have been here for twenty days now. I have

The little colonial town of Papeete was already thoroughly Westernized by the late 1800s. Only by moving farther away was Gauguin able to discover

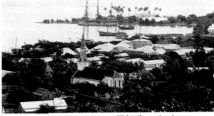

Tahiti's majestic scenery and unspoiled native life.

already seen so many new things that I am thoroughly discomposed. I'll need still more time before I can paint a picture."

Thoroughly disappointed was how he really felt when he landed at Papeete, a small, undistinguished colonial port with tin-roofed houses and a high cost of living. For the most part, his search for guileless "savages" turned up prostitutes plying their trade in the market district, Chinese tavern-keepers, and bibulous colonials. The fact that he had not yet begun to paint did not stop him from wildly celebrating during the Bastille Day festivities, which lasted for weeks.

At first he hoped to make a living in Papeete by painting portraits. Freshly shaven and dressed like a colonial, he hobnobbed for a while with the local smart set in the officers' club. Unfortunately, the only known commission to come out of it was requested by an eccentric Englishwoman who had married a Maori chief from the Leeward Islands of French Polynesia. Gauguin's superb but unflattering portrait of Suzanne Bambridge did not make him a fashionable painter in the community. Shortly after his arrival the artist attended the funeral of Pomare V, the last king of Tahiti. He felt as though he had definitely arrived too late in a world that was fading out of existence. In late September he moved to Mataiea, a district nearly fifty miles from the center of town. His companion at the time was Titi, a young mulatto woman who returned to Papeete soon afterward.

Mataiea-by-the-Lagoon

Gauguin's quest for authentic Tahitian life and scenery had come to an end. "Everything about the countryside dazzled and blinded me. Coming as I did from Europe, I was always uncertain about this or that color; I looked for difficulties where none existed. And yet, it was so simple [to paint things as I saw them], to put a red or blue on my canvas" (*Noa Noa*). "As yet I have done nothing striking," he wrote to Monfreid on 7 November 1891. "I am content to delve into my innermost self, not nature, and to learn [a little] how to draw.... Besides, I am building up a supply of documents [drawings] for paintings when I get back to Paris."

The spot Gauguin had chosen (now the site of the Musée Gauguin) was indeed superb, but more than five hours from town by horse-drawn carriage—a telling example of his precipitate decisions. During the celebrations in Papeete he had met the chief of the Mataiea district, Tetuami, who was the most Francophile of the island's chiefs and the colony's representative at the 1889 World's Fair in Paris. (Bengt Danielsson, a navigator and ethnologist, turned up this interesting detail in the course of his outstanding study of Gauguin's Tahitian and Marquesan periods back in the 1950s, when it was still possible to reconstruct from interviews an unromanticized chronicle of the painter's life.) Try though he might, Gauguin never managed to learn Tahitian; and he must have been relieved to befriend a man who suggested he move to more genuinely primitive surroundings, yet who spoke French and also shared his frame of reference.

Preliminary drawing for the painting *Nafea Faaipoipo (When Will You Marry?)*.

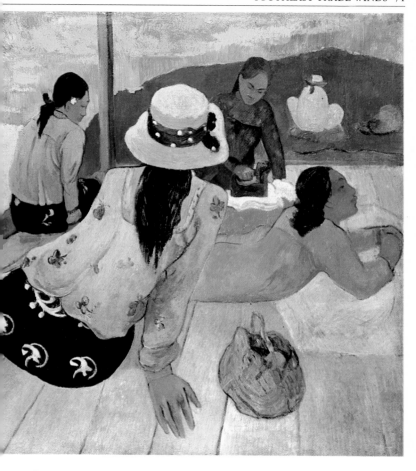

"Mataiea is one of the most beautiful parts of Tahiti," writes Danielsson, "both because the coastal plain here is exceptionally wide, so that the mountains are not too near and can therefore be seen in all their splendor, and because the surf along the coral barrier which shelters the lagoon is higher and more sparkling than anywhere else, owing to the ceaseless southeast trade winds at this point. Furthermore, the lagoon is exceptionally beautiful by reason of its palm-clad islets...."

Domestic Scene on a Veranda, often called The Siesta (1892). The visitor with her back to us has come to chat in the shade with her friends, one of whom is ironing.

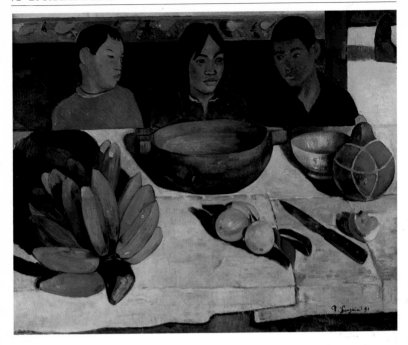

"I Can Feel It All About to Take Hold of Me"

At long last Gauguin had found a setting that lived up to his dreams. He took heart anew and rented a modest *fare*, or bamboo hut with a thatched roof. Although the wonderful scenery around him inspired an occasional painting (*Under the Pandanus, The Burao Tree*), he was especially intent on recording the everyday life of attractive, good-natured natives whose extremely terse verbal exchanges made them seem that much more mysterious. His best drawings of these serious, attentive Tahitian faces date from the early months of his stay. In the same way that he had in Brittany, he soaked in the character of locals and locales, the mingled splendor and melancholy peculiar to tropical places and their inhabitants. "As I write to you it is evening," he wrote to Mette. "The stillness of night in Tahiti is the strangest thing of all. It exists nowhere but here, without so much as a birdcall to disturb one's rest. Here and there a large

The subject of *Tahitian Repast* (1891) is an exotic still life with three attentive and self-conscious children looking on. In the foreground, a superb bunch of bananas (*fei* in Tahitian), a motif Gauguin used on several occasions for its dazzling color and powerful decorative effect.

dry leaf falls but without making the slightest sound. It is more like the rustling of a spirit. The islanders often move about at night, but barefooted and silently. Always this silence. I understand why these individuals can remain seated for hours and days without uttering a word, gazing mournfully at the sky. I can feel it all about to take hold of me, too." The paintings from the first few months of his stay—*On the Beach, The Bananas, Te Faaturuma (Brooding Woman), The Siesta*—capture the poetry of this immobility and torpor, which apparently Gauguin found very striking. Everything weighed him down. In *Man with an Ax* even a subject hard at work seems to have been frozen in mid-stroke by melancholy reverie.

"The Vigorous Glow of Suppressed Strength"

In *Noa Noa* Gauguin commented at length on his first portrait, *Vahiné No Te Tiare (Woman with a Flower)*. "To really get to know the character of a Tahitian face, all the charm of a Polynesian smile, I long wished to do a portrait of a neighbor of mine, a woman who was pure Tahitian.... She wasn't pretty by European standards, but beautiful just the same. All the features of her face curved together with a Raphael-esque harmony. Her mouth was modeled, as if by a sculptor, for all the languages of speaking and

Ta Matete (The Marketplace) records a scene actually observed: the willing young prostitutes of Papeete, seated in a neat row like goods on display. The painting is also a re-worked version of an Egyptian tomb painting from Thebes, a photo-graph of which was in Gauguin's possession.

One of the many handsome Tahitian faces Gauguin began drawing as soon as he arrived (left).

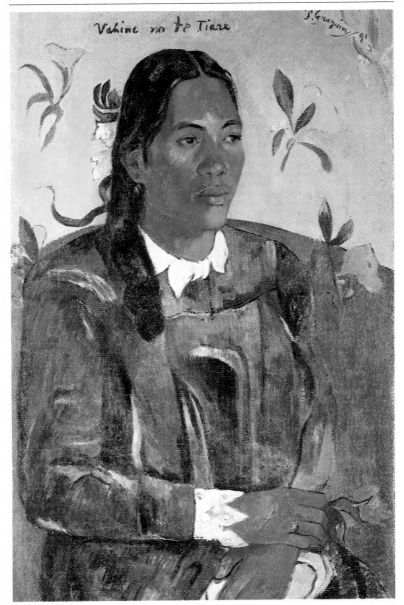

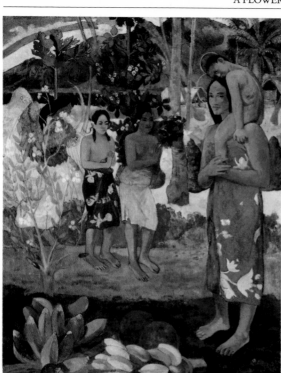

Ia Orana Maria

According to *Noa Noa*, the *Woman with a Flower (Vahiné No Te Tiare)* was the first Tahitian woman to agree to pose for Gauguin (far left).

Ia Orana Maria (left) is Tahitian for "Hail Mary." In 1891 Gauguin himself described to Daniel de Monfreid this South Seas interpretation of a biblical image: "An angel with yellow wings points out to two Tahitian women Mary and Jesus, who are also Tahitian...nudes dressed in *pareus*, a kind of flowered cotton cloth that can be wrapped as one likes about the waist. Very dark background with mountains and flowering trees. Dark violet footpath and emerald green foreground. On the left, some bananas. I'm rather happy with it."

kissing, of joy and sorrow; it had the melancholy of bitterness mingled with pleasure....This portrait was a likeness of what my eyes *veiled by my heart* had seen. Chiefly faithful, I think, to what lay within. That vigorous glow of suppressed strength. She had a flower behind her ear, listening to its fragrance. And her forehead, in the majesty of its upsweeping lines, reminded me of Poe's statement: 'There is no perfect beauty without some singularity in proportions.'"

Ia Orana Maria

The Mataiea district differed from the rest of the island in that its native residents were Catholic instead of Protestant. Was it in church that Gauguin heard the

opening words of the Ave Maria in Tahitian? The painting *Ia Orana Maria* is an exotic counterpart to *The Yellow Christ* or *The Vision After the Sermon*, a syncretistic scene that illustrates primitive devotion by transplanting a biblical subject to an alien, anachronistic world.

It is as if Gauguin had superimposed two scenes while lost in a dream: one real (a Tahitian Mary and Jesus in the foreground near a sumptuous still life with bananas), the other imaginary and "artistic" (an angel inspired by Botticelli and two praying women based on photographs he had of relief carvings from Borobudur), all held together by an opulent palette of predominantly yellow, red, and blue. After describing it at length in a letter to Monfreid (March 1892), Gauguin concluded, "I'm rather happy with it."

Fatata Te Miti (Near the Sea), 1892. The sight of young Tahitian women swimming must have enthralled the painter: Here was a typically primitive Edenic scene as well as a ready source of graceful, spontaneous models. Exuberant colors and decorative patterns (foreground) played an increasingly important part in Gauguin's paintings.

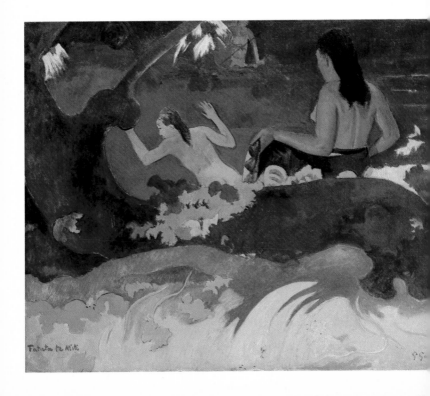

Fatata te Miti

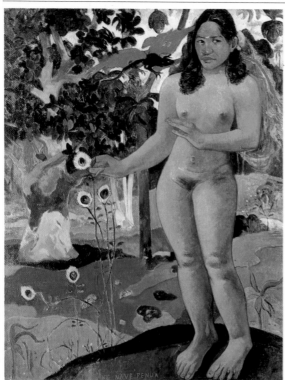

THE YOUNG TAHITIAN woman in *Te Nave Nave Fenua (The Delightful Land)* strikes a pose inspired by reliefs from the temple at Borobudur, plaster casts of which Gauguin had seen at the 1889 Paris World's Fair. The apple of this Tahitian Eve has turned into an imaginary flower in the shape of a peacock feather, and instead of a snake—there were no snakes in Tahiti—there is a fabulous lizard with scarlet wings.

THIS carved and polished wooden portrait of Tehamana shows Gauguin's *vahiné* with a flower behind her ear.

Tehamana

"I am hard at work, now that I know the native soil and its smell. The Tahitians, whom I am painting in a very enigmatic fashion, are still Maoris [Polynesians] and not Orientals from the Batignolles [artists' quarter in Paris]. It has taken me nearly a year to come to understand this" (July 1892).

He left out one important detail in his letter to Mette. If from now on Gauguin was such an authority on Tahitians, it was because he himself was living with a pretty thirteen-year-old Polynesian girl. Beautiful, stolid, untalkative, she seems to have been the primitive Eve of his dreams and sat for his finest pictures of 1892–3.

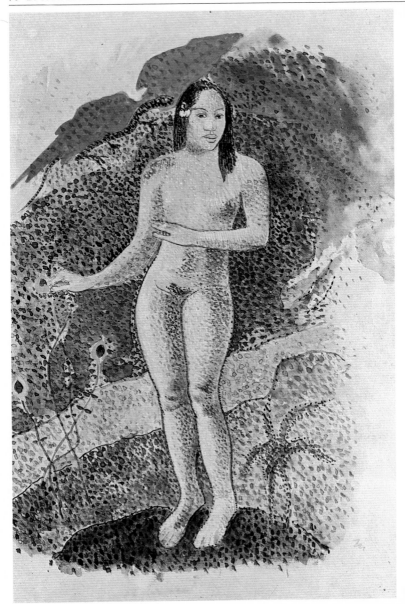

The pointillist watercolor on the opposite page is a variation on the painting *Te Nave Nave Fenua (The Delightful Land)*, which represents the Tahitian Eve of Gauguin's earthly paradise.

Two folios from the illustrated manuscript of *Noa Noa*. Above: A watercolor of two Polynesian deities. Below: Gauguin glued a woodcut depicting Hina and Fatu and a photograph of a Tahitian convert bedecked in flowers to a page with a watercolor sketch..

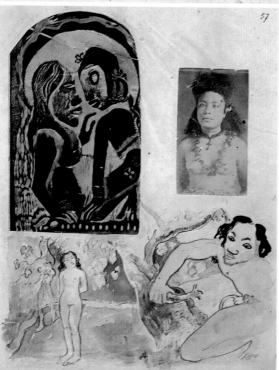

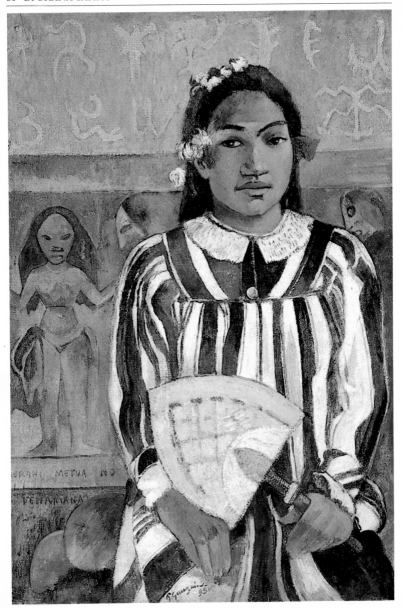

Her stubborn yet winsome face and dark, sturdy little body grace famous paintings in museums the world over: *Woman with a Mango, Te Nave Nave Fenua (The Delightful Land), Manao Tupapau (Spirit of the Dead Watching), Mehari Metua No Tehamana (The Ancestors of Tehamana).* Gauguin tells us how he set out to explore the island and happened upon a less-civilized district where he was offered a *vahiné,* Tehamana, whom he refers to as Tehura in *Noa Noa,* the somewhat embellished account he wrote later in Paris.

The dignified, regal figure in *Mehari Metua No Tehamana (The Ancestors of Tehamana)* is Gauguin's mistress, and the imaginary decoration behind her is intended to evoke ancestral secrets (far left). The drawing at left may be a study for the painting. The young Tahitian woman in the photograph below is wearing a dress similar to Tehamana's.

"I started working again, and happiness came on happiness. Every day, at the first glimmer of sunrise, the light inside my room was radiant. The gold of Tehura's face flooded everything around it, and the two of us would go, in all naturalness and simplicity, as in the Garden of Eden, to seek refreshment in a nearby brook.... My new wife was not very talkative; melancholy and mocking. The two of us kept studying each other. She was impenetrable; I was quickly beaten in that contest. In spite of all my inner resolve my nerves soon got the better of me and in a very short time I was, for her, an open book."

Out of his entire South Seas exile it seems that only during these few months did reality live up to Gauguin's dream vision of paradise on earth. It was a time of domestic calm, filled with affection and sensual delight, as well as intense artistic activity.

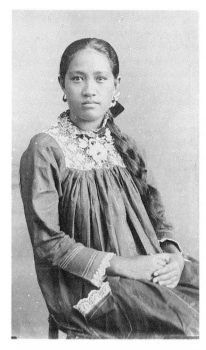

Spirit of the Dead Watching

In *Noa Noa* Gauguin states that the tales his *vahiné* told him helped him gain a better understanding of ancestral religious beliefs. Actually, it was not that way at all. As neither knew the other's language, their conversations were extremely limited. In any event, the traditions had been forgotten. The truth is that Gauguin researched the subject on his own. One of his source books, lent to him by a colonial from Papeete, was *Voyages aux Iles du Grand Ocean*, which J.-A. Moerenhout had written a half-century earlier. It proved a mine of information about ancient Polynesian religions, rituals, and ancestral customs. It was the basis for a number of Gauguin's manuscripts, in particular, *Ancien Culte Mahorie*, a concise compilation of myths with watercolor illustrations, and, best known of all, *Noa Noa*, which he wrote after his return to Paris. His fascination with these tales and legends is reflected in several paintings, including *The Birth of the Areois* (depicting a goddess believed to dwell on Bora Bora) and *Vairumati.* However, as always, he was adept at blending fact and fiction. Case in point: *Manao Tupapau (Spirit of the Dead Watching).*

In the first draft of *Noa Noa* Gauguin tells us how he got the idea for this painting. "One day I had to go to Papeete. I had promised to come back that evening, but [delayed,] I didn't get home until one in the morning. Just then we were very low on fuel for lighting; my supply was due to be replenished. The lamp had gone out, and when I went in the room was in darkness. A kind of fear came over me—above all, suspicion.

Surely the bird had flown away....
I struck some matches and saw
Tehamana, naked, motionless, her
eyes wide with fear, gazing at me as
though she didn't recognize me."

And this is how he transformed
what he saw into myth, a work of art,
a Polynesian "icon." "A young native
woman is lying flat on her stomach,
with only part of her terror-stricken
face visible. She is resting on a bed
which is draped in a blue *pareu* and a
light chrome-yellow sheet. A
purplish-violet background strewn
with flowers that look like electric
sparks. A rather strange figure stands
by the bed.

"Beguiled by a form, a movement,
I paint them with no other intention
but to do a nude. As it stands, the
study is a little indecent. And yet, I
want to do a chaste picture, one that
conveys the native mentality, its
character, its tradition.

"As the *pareu* plays such a vital part
in a native woman's life, I use it as
the bottom sheet of the bed. The top
sheet, made of bark-cloth, has to be
yellow, because that color creates
within the viewer a feeling of the
unexpected. Also because it creates
the illusion of a scene lit by a lamp,
thus making it unnecessary to
simulate lamplight. The background
must seem a little terrifying; violet is
just the right color. There you have a
complete outline of the musical part
of the picture. In this rather daring position, stark naked
on a bed, what might a young native girl be doing?
Getting ready to make love? That is in her character, but
it is indecent and I do not want that. Sleeping after the
act of love? That is still indecent. The only thing I see is
fear, but not the fear of Susannah surprised by the Elders.

The model for *Manao Tupapau (Spirit of the Dead Watching)*, reversed and in watercolor, reappears in this folio from *Noa Noa*, the illustrated manuscript Gauguin later drafted in Paris in order to make his Tahitian paintings more intelligible.

An illustration from the *Ancien Culte Mahorie* manuscript.

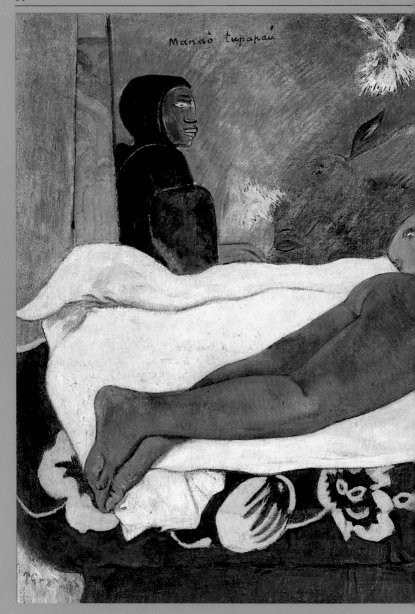

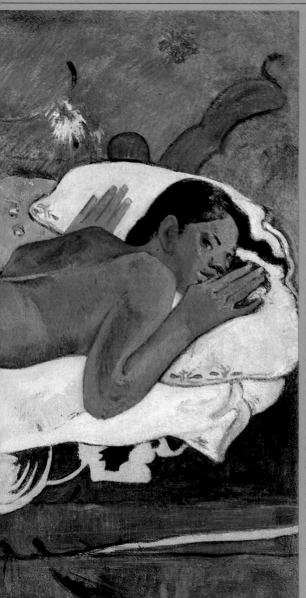

The Spirit of the Dead

One of the reasons Gauguin's exhibition of Tahitian paintings proved largely unsuccessful was their Tahitian titles. Case in point: *Manao Tupapau*. In artistic circles this quasi-ethnographic insistence on elucidating local mythology was considered somewhat pointless and tiresome. Pissarro, for one, berated him for "pillaging the savages of Oceania." At times Gauguin seemed so anxious to be understood that he was willing to risk being overly explicit. But his real supporters were not put off by this conspicuous admixture of folklore. The exotic sumptuousness of the Tahitian oils struck a chord in Degas, for example. The model's face and the *tupapau* reappear in a woodcut Gauguin produced in Paris in 1894 (above).

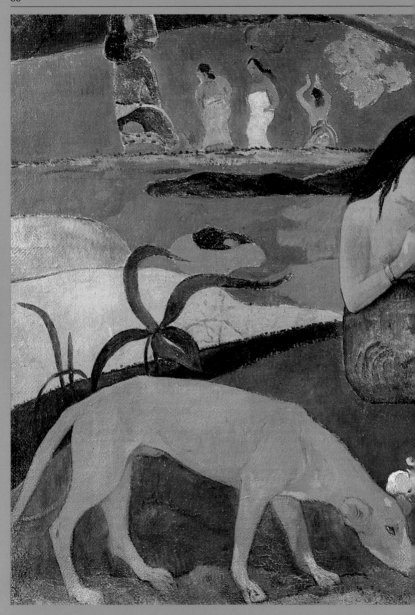

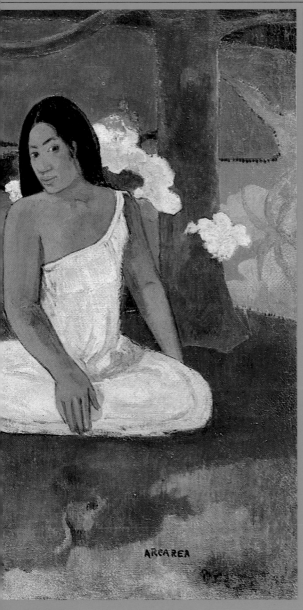

Bucolic Lagoon

In the pastoral *Arearea (Joyousness)*, 1892, a woman playing a Tahitian flute (*vivo*) and her attentive companion sit under a tree on the shores of a lagoon. Visitors at the Durand-Ruel exhibition of Gauguin's Tahitian work in 1893 were particularly amused—or horrified— by the red dog in the foreground. The women in the background are dancing the *tamure* in front of an imaginary Polynesian idol.

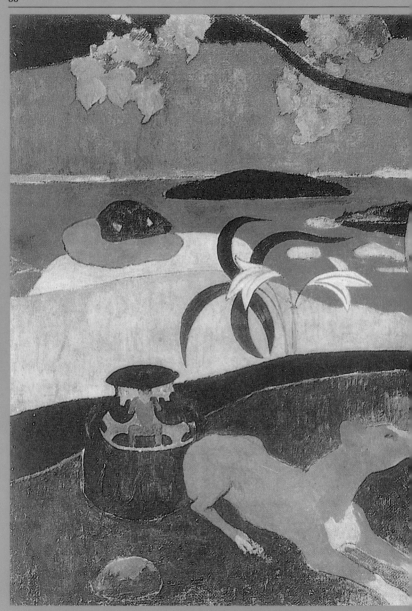

Pastorales Tahitiennes
1893
Paul Gauguin

"Pure Veronese Green and Pure Vermilion"

Gauguin described this as his best current painting in a letter to Daniel de Monfreid (December 1892): "For once I gave it a French title, *Pastorales Tahitiennes*, as I could not find an equivalent in the Kanaka language. I don't know why—laying on pure Veronese green and pure vermilion—but it looks to me like an old Dutch painting or an old tapestry."

"The obvious [explanation] is the *tupapau* [spirit of the dead]. The natives live in constant fear of them and always leave a lamp lit at night.... My feeling for the decorative leads me to strew the background with flowers. These are *tupapau* flowers, phosphorescent emanations, a sign that the ghost is looking after you. That is the Tahitian belief....

"To recapitulate. Musical part: undulating horizontal lines; harmonies in orange and blue connected by yellows and violets, their derivatives. Illuminated by greenish sparks. Literary part: the spirit of a living girl linked with the spirit of the dead. Night and day.

"This account of how the picture originated is written for those who must always know the whys and wherefores. Otherwise, it is simply a study of a South Seas nude."

At the End of His Tether

Despite the magnificent work Gauguin turned out during these months, despite his *vahiné* (who, it seems, was also growing weary), loneliness weighed heavily on him. Worn out by financial difficulties— he was penniless and getting nothing from Europe—he was now anxious to head back. The fact that he had not sold anything in eighteen months plunged him into despair. "I shall have to give up painting once I get back," he wrote to Monfreid. Lo and behold, our man of perpetual departures was longing to be reunited with his family and looking into the possibility of getting appointed a drawings inspector in schools in France. "It would mean for us, my dear Mette, a secure old age,

This large pastel is a study for the central figure in *Parau Na Te Varua Ino (Words of the Devil)*. Both the title and the Tahitian girl's modesty recall the theme of Eve driven from the Garden of Eden.

happily reunited with our children. No more uncertainty" (April 1893).

He described himself as being "at the end of [his] tether" in May 1892, and he fared no better that summer. He was reduced to appealing to the governor for repatriation. Ominous clouds seemed to be gathering. Albert Aurier, the young critic and staunch Gauguin supporter, had just died at the age of twenty-seven. Theo van Gogh, until then his one and only dealer, had died in 1891. "We are certainly having bad luck" was Gauguin's comment.

On balance, however, gains outweighed losses. In less than two years Gauguin had painted some eighty generally excellent pictures. One of the last, *The Ancestors of Tehamana*, is considered a kind of farewell to his "Tahitian wife." She has been turned into a mysterious princess despite her "missionary dress," the modest garment missionaries encouraged Tahitian women to wear instead of the *pareu*. Behind her we see a Polynesian idol and hieroglyphs that are not at all Tahitian, but an undecipherable form of writing discovered on Easter Island. Everything conspires to invest Tehamana with enigmatic dignity, the primitive nobility that Gauguin himself hoped to recapture through his painting.

We do not know what Tehamana felt—*moe moe* (dejection) or *haapao'ore* (indifference)—when, on 4 June 1893, Gauguin, having finally been granted free third-class passage, boarded the *Duchaffault* for the return trip to France.

He arrived in Marseilles on 30 August with four francs in his pocket and wired the dependable Daniel de Monfreid for his train fare back to Paris.

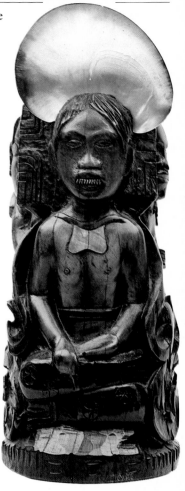

Idol with a Shell, one of Gauguin's "ultra-barbaric sculptures." This terrifying god with a cannibal's teeth assumes the lotus position of the Buddha at Borobudur.

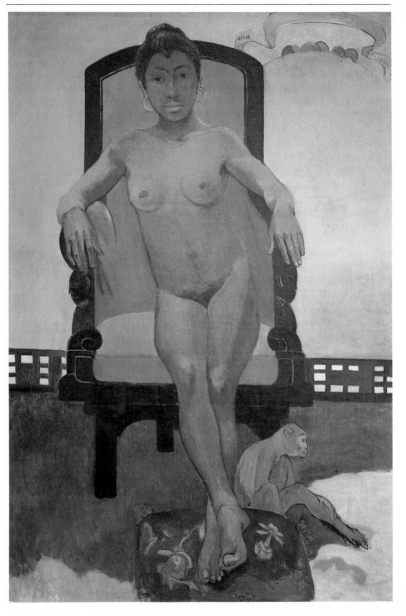

September 1893. Gauguin pinned all his hopes on this return to Paris: recognition of his talent, financial success, and above all the heart-warming company of his friends. As it turned out he found himself alone, or nearly so. Vincent and Theo van Gogh, Albert Aurier, and Meyer de Haan were dead. Laval was dying. Mette, Monfreid, and Séguin were away. And his relations with Pissarro and Emile Bernard had deteriorated.

CHAPTER V
THE TROPICS IN MONTPARNASSE

The model in this nude portrait is Gauguin's mistress, Annah la Javanaise, as she appeared in 1894. Left: One of the woodcuts for *Noa Noa*.

Gauguin moved into a two-room apartment on Rue de la Grande-Chaumière, and soon things were taking a slight turn for the better. Alphonse Mucha offered him the use of his studio; he came into a small legacy from his uncle in Orléans; and he got back in touch with Daniel de Monfreid, Degas, and Charles Morice. With their help, he made preparations for a one-man show of his Tahitian work at Durand-Ruel's. He also decided to write a book "to help people understand my painting": the future Noa Noa, which, unfortunately, Charles Morice "tidied up" to a fault. Before that Gauguin had attempted to donate Ia Orana Maria, which he considered his most accomplished Tahitian picture, to the Musée du Luxembourg. Needless to say, they turned it down out of hand.

On 10 November 1893 Gauguin's First Major One-Man Show Opened

Some forty canvases that Gauguin had rolled up and shipped from Tahiti were stretched and mounted in white, yellow, or blue frames. "This exhibition," Rotonchamp later wrote, "was an undeniable success in terms of the curiosity it aroused, but commercially it proved a disaster. The public was baffled, not so much by the peculiarity of the artist's technique as…by his preoccupation with the literary and the paleo-ethnographic."

Gauguin's onetime teacher Camille Pissarro summed up the reaction of the artistic community. "Gauguin is currently doing a show that has won the admiration of the literati. They are enraptured, or so it appears.

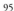

The Swedish cellist Fritz Schneklud, one of the regulars at Gauguin's studio on Rue Vercingétorix. Possibly Gauguin had Degas' orchestra scenes in mind; at any rate, here he chose to emphasize the cello's decorative shape and reddish-orange color. This painting recalls the many analogies he drew between music and color in his writings.

Symbolist poet Charles Morice, who helped Gauguin prepare *Noa Noa* for publication (far left).

The collectors, they tell me, unanimously consider this exotic art too caught up in South Seas islanders. Only Degas thinks highly of it. Monet and Renoir find it simply bad. I saw Gauguin. He expounded on his theories about art and assured me that the young would find salvation by replenishing themselves at faraway, savage sources. I told him that this art did not belong to him, that he was a civilized man…. We parted both unconvinced." Not difficult to imagine!

Fortunately for Gauguin some critics—and not just the Symbolist poets—were enthusiastic, including Thadée Natanson in *La Revue Blanche*, at the time the leading review of the literary and artistic avant-garde.

Gauguin (center) posed for a photographer at the Durand-Ruel exhibition. Behind him can be seen part of *Te Faaturuma (Brooding Woman)*, which Degas bought for his own collection.

The Montparnasse Studio: A Self-Promoting Showcase

In January 1894 Gauguin moved into a studio on Rue Vercingétorix, almost where it intersects Avenue du Maine. He painted the walls brilliant chrome yellow and olive green; he also painted the windows, one with a Tahitian couple making love (*Te Faruru*). It was more than a residence or a studio. For Gauguin it was a kind of private gallery calculated to promote his work and showcase his Tahitian pictures. The walls were decorated with reproductions of works by his favorite painters—Cranach, Holbein, Botticelli, Puvis de Chavannes, Manet, Degas—and "originals [by those] he rated highest—van Gogh, Cézanne, Redon—which Schuffenecker and Daniel de Monfreid must have stored for him during his absence" (Danielsson). There were also "trophies, war paraphernalia, axes, boomerangs, tomahawks, pikes, spears, all made of some unknown wood," his future biographer, Rotonchamp, tells us. "On the mantelpiece were displayed a variety of mineralogical specimens and shells.... In this exotic decor that recalled the pied-à-terre of a naval officer and the intermittent home of an explorer, one felt far, very far, from Paris."

Even the self-portraits from this period seem to be part of a desperate strategy to compel recognition. The same was true of his astonishing (and, for some, exasperating) outward appearance: He turned himself into an outlandish specimen, another work of art in the total oeuvre that was Paul Gauguin. "He invented everything," Armand Séguin later recalled. "His easel was his invention, as was his method for preparing canvases and his process for reproducing watercolors.... He also invented a bizarre way of dressing. This consisted of an astrakhan hat and a huge dark blue overcoat held together with finely tooled buckles, in which he looked to Parisians like a gorgeous, gigantic Magyar, or like Rembrandt in 1635. As he made his

These woodcuts are part of the series Gauguin carved for *Noa Noa*. Above: *Te Faruru (Making Love)*. Right: Two impressions of *Te Nave Nave Fenua (The Delightful Land)*, one in black, the other heightened with colors.

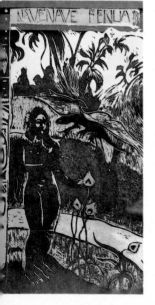

slow, stately way along the street, he leaned with one white-gloved, silver-ringed hand on a cane that he himself had carved."

Annah la Javanaise

Gauguin must have cut an even more spectacular figure when accompanied by Annah "la Javanaise" and her pet monkey. This young mulatto woman, whom Gauguin probably met through Ambroise Vollard, was his mistress from December 1893 to the fall of 1894, at which point she left Gauguin in Pont-Aven and returned to Paris to ransack his studio. However, the painter had her to thank for the masterpiece of this European stint (page 92). The short, stocky half-breed is shown enthroned like a naked queen on a peculiar

Photograph of a social and musical gathering at Gauguin's studio on Rue Vercingétorix, 1894, with cellist Fritz Schneklud seated in the center. Standing, left to right: Paul Sérusier—painter of *The Talisman*—Annah la Javanaise, and sculptor Georges Lacombe, one of the future Nabis.

quasi-Chinese, quasi-Polynesian chair which, like the baseboard molding, probably did not exist. The pink wall, blue armchair, and yellow floor—also apparently contrived, as the actual studio had chrome yellow walls—make for a strident color combination aimed at highlighting the insolent presence of the exotic nude.

"It Is Extraordinary That So Much Mystery Can Be Put Into So Much Brilliance"

In his memoirs Gauguin proudly quoted this statement by Mallarmé. He was a regular at the poet's Tuesday evening receptions. Another poet, Henri de Régnier, recalled the painter's appearances in the home of the poet whose verse *"Fuir! là-bas fuir!"* ("Escape! Escape to far away!") seemed more the leitmotif of Gauguin's life than of his own. "In contrast with Redon's silence, I can still hear, it seems, Gauguin's gruff, raucous voice. Between two of his trips to Tahiti, he showed up several times at the Tuesday soirées. He'd let his bulky body sink ponderously into a chair. The sailor's jersey he'd be wearing, his rugged face, swarthy complexion, and huge hands gave an impression of strength and coarseness that was a foil to Mallarmé's exquisite civility and extremely distinguished presence. Mallarmé looked like the skipper of a delicate pleasure craft that had known no adventures save those encountered while cruising up and down the Seine, whereas Gauguin looked like the captain of a coasting vessel that had skirted distant shores washed by Polynesian seas."

Gauguin admired Mallarmé and did a superb portrait etching of him shortly before he left for Tahiti. Although the poet did not write directly on

Annah la Javanaise, c. 1898, photograph by Alphonse Mucha. Above: Annah's pet monkey at her feet, as seen in a detail of the 1894 painting (p. 92).

the painter's behalf, on several occasions he did use his influence in literary circles to get favorable articles written about him. "I am profoundly grieved," Gauguin wrote to Monfreid from the South Seas when he learned of Mallarmé's death in 1898. "He is another who died a martyr to his art, and his life was at least as beautiful as his work."

Gauguin's January 1891 portrait of Mallarmé is the only etching the artist ever produced.

Gauguin Through a Poet's Eyes

Judging by the many descriptions we have of Gauguin, he did not need bizarre getups to attract notice. According to Charles Morice, he had "a large, bony, bulky face, with a narrow forehead and a nose...neither beaked nor curved, but broken-looking. His mouth was straight and thin-lipped; his eyes...slightly bulging, with bluish pupils that swiveled in their sockets to the left or right, while his head and upper body made almost no effort to turn."

Morice goes on to describe him as "possessed of little charm. Nevertheless, he attracted people by his singular demeanor. This was a blend of nobility, obviously innate, pride, and a simplicity that bordered on banality. One quickly realized

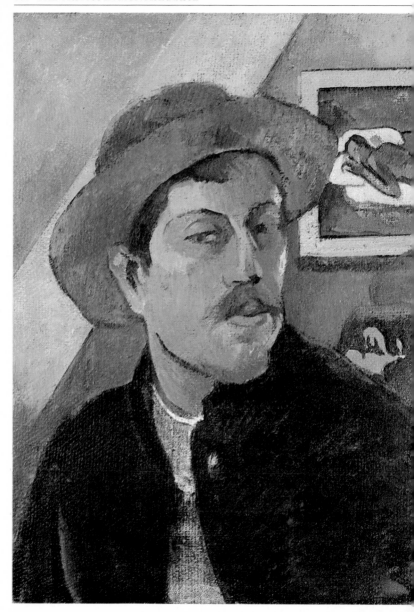

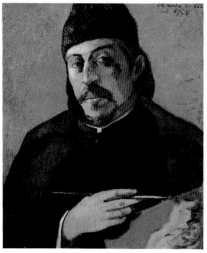

that this mixture was a sign of strength: aristocracy revitalizing itself among the common people.

"Also, Gauguin may have lacked grace, but he had a strangely sweet and ingenuous smile: a smile that did not go very well with those too-straight, too-thin lips, which when they relaxed seemed to regret, even to deny any admission of gaiety as if it were a weakness. Above all, his head took on real beauty when its seriousness lit up in the heat of argument."

Noa Noa: A Book and Some Woodcuts

During the Paris period Gauguin was chiefly involved in two undertakings: reworking the notes he had made in Tahiti into drafts of what would be two splendid illustrated manuscripts (*Ancien Culte Mahorie* and *Noa Noa*), and turning out a large number of woodcuts and monotypes based to varying degrees on his Tahitian paintings.

Underlying this twofold activity as writer and artist was the fact that at this juncture the painter was obsessed with elucidating and disseminating his Tahitian work, which he despaired of getting people to grasp and admire.

The result was a series of superb prints on Edenic

Gauguin's studio is the setting for *Self-Portrait with Hat* (far left). Behind him we see his fetish painting *Manao Tupapau*, some Tahitian fabric draped over a settee, and the walls he painted yellow. Gauguin painted a portrait of his friend William Molard on the verso of this canvas.

A photograph of the painter in his famous astrakhan hat (above right). *Self-Portrait with Palette* (above left), based on this photograph, was dedicated and given to Charles Morice, Gauguin's champion in the Symbolist press.

themes: *Auti Te Pape (Women at the River), Noa Noa (Fragrant), Te Faruru (Making Love), Te Nave Nave Fenua (The Delightful Land), Pape Moe (Mysterious Water), Oviri (Savage)*.

He delighted in devising new processes and drew on the tradition of the monotype (already revived by Degas) and the technique of scumbling to create watercolor transfers and printed drawings. In short, he produced a body of works on paper that were both "primitive" and sophisticated, halfway between drawing and engraving.

Oviri: "Strange Figure, Cruel Enigma"

For quite some time—since Brittany—Gauguin enjoyed labeling himself a "savage." In 1894 he returned to pottery making and produced what he himself described as his most astonishing ceramic sculpture ever: *Oviri* (Tahitian for "savage"). It is a large stoneware figure of a long-haired woman with a moonstruck expression shown crushing a bloodied wolf against her leg. Subsequently, Gauguin also referred to the scupture in his letters as *La Tueuse (The Murderess)* and treasured it so much that he wanted it placed on his grave in the Marquesas "and before then in my garden."

This mysterious woman, described on the *Oviri* woodcut dedicated to Stéphane Mallarmé as a "strange figure, cruel enigma," reflects an especially distressing and desperate period in Gauguin's life. It coincided with the artist's ultimate decision to leave France without any hope of being understood, as if the crushing defeat, savagery, and death symbolized by *Oviri* had provided him with one last impetus to create.

It is important to note that this violent, mysterious, "primitive" sculpture had a profound effect on younger artists when it was exhibited publicly as part of the Gauguin retrospective in Paris at the Salon d'Automne of 1906. Pablo Picasso, for one, was probably inspired to use *Oviri* as the basis for one of the figures in *Les Demoiselles d'Avignon*.

"I proudly maintain that no one has ever done this before," wrote Gauguin about his stoneware sculpture *Oviri* (right).

An impression of the woodcut version of *Oviri*, dedicated "To Stéphane Mallarmé, this strange figure, cruel enigma."

"Finish Out My Life and End My Perpetual Struggle with the Imbeciles"

Despite all his efforts a year in Europe had left Gauguin feeling utterly defeated. Indeed, troubles seemed to be coming thick and fast. In the summer of 1894, he went back to Pont-Aven to retrieve the paintings and sculptures he had left in Marie Henry's keeping in Le Pouldu before going to Tahiti. She refused to return them, contending that they had become her property in exchange for her hospitality. He sued to get them back and lost.

Then Gauguin suffered a fracture during a scuffle that broke out when some sailors roughed up Annah and her monkey in the port of Concarneau. His leg did not heal properly. Incapacitated, he was unable to work for four months and forced to take drugs for the pain. Lastly, he put up some of his work for auction at the Hôtel Drouot to finance his final departure. It proved a stinging failure. There was a last visit with Mette and the children in Copenhagen, and he came away feeling he had failed there, too.

By the fall of 1894 he had informed Monfreid of his decision to leave France for good. "My suffering has cost me all my courage, especially at night, when I do not get a wink of sleep.... I've made up my mind to go away to the South Seas and never come back. I'll return to Paris in December for the sole purpose of selling everything I possess no matter what I get for it. If all goes well, I'll leave right away... and then I'll be able to finish out my life a free man, my mind at ease, and end my perpetual struggle with the imbeciles.... Farewell, painting, except for what I do for my own amusement. My house will be made of carved wood."

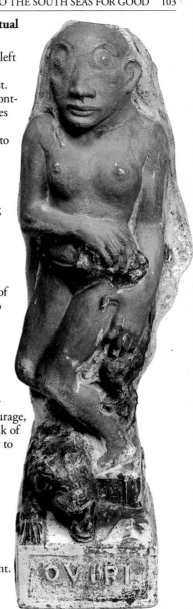

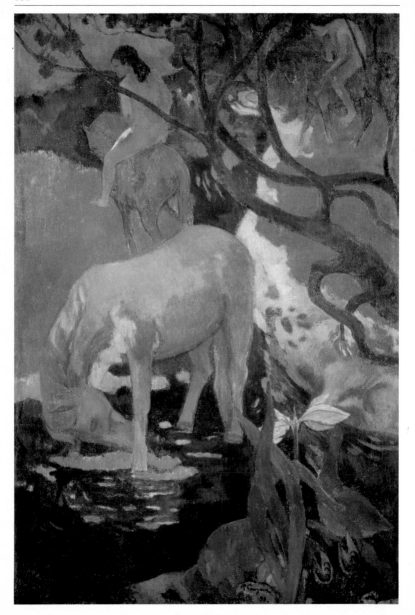

The Gare de Lyon, Paris, 28 June 1895. According to witnesses, Gauguin was in tears. He was starting out on his last trip to the South Seas. Desperate, alcoholic, ailing, and all alone, he was about to achieve a true nobility that no amount of conceit, bluster, or scheming could ever tarnish.

CHAPTER VI
A LAST SPARK OF
ENTHUSIASM

More green than white, *The White Horse* (opposite), with Tahitian riders glimpsed through branches, is fairly typical of the second Tahitian period, when Gauguin favored human figures set amid lush vegetation. Undated sketch of Tahitian women (left).

Gauguin landed at Papeete in early September 1895 after
a two-month journey that included two stopovers: one at
Port Said, too brief to take in the relics of Egyptian art he
so admired (but long enough to stock up on obscene
postcards, which later adorned his hut in the Marquesas
to the delight or indignation of his neighbors!), and a
more significant one at Auckland, New Zealand, where
he closely examined
collections of Maori art in
a recently opened wing of
the Ethnological Museum.

Collections of Maori
art in the Auckland
Ethnological Museum, as
they appeared when
Gauguin viewed them.

Tahiti: Paradise or Hospital?

The first months were
especially disheartening.
Disappointed to find that
Tahiti had become
increasingly Westernized,
he quickly laid plans to
move on to less-civilized
surroundings and even
then contemplated the
Marquesas Islands. But
Gauguin was never again
to be a well man. His

prolonged hospital stays in Papeete make for a poignant
list: July 1896, January 1897, December 1897,
September 1898, December 1900, February–March
1901, not to mention routine medical care between
hospitalizations. Everything seemed to hit him at once:
complications from his open leg fracture in Concarneau;
aftereffects of syphilis; heart trouble; probably
alcohol abuse; and skin rashes, which were mistaken
for leprosy and frightened Tehamana away soon after
he had sent for her.

A new fourteen-year-old *vahiné*, Pahura, and new
friends in Tahiti's French community did not alleviate
Gauguin's deepening loneliness. He had to face facts:
Despite his expectations, not one of his friends and
"pupils" from Pont-Aven would come out to join him.
(Séguin and Roderic O'Conor had once given it serious

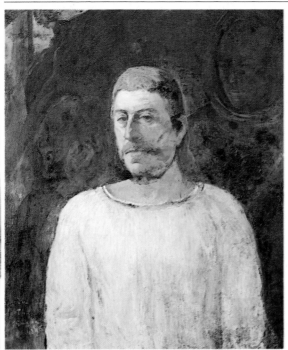

Shortly after Gauguin's death Victor Segalen visited his studio in the Marquesas Islands. Among the paintings found was *Self-Portrait Near Golgotha* (summer 1896), which he described as "a very accomplished...self-portrait, a powerful, erect torso set against a distant backdrop of what appear to be crucifixes. Thickset build, lips drawn down, eyelids heavy."

thought.) Feeling that, all things considered, his recent stay in Paris had ended in failure, he lapsed into a deep depression. "What have I achieved?" he asked Monfreid in a letter from April 1896. "Utter defeat. Nothing but enemies. Bad luck has dogged me relentlessly.... The farther I go, the lower I sink.... Many people always find support because their weakness is known, and they know how to ask. No one has ever helped me because people think I'm strong, and I was too proud.... I am nothing but a failure."

"The Enigma Hidden Deep in Her Eyes"

Yet, in this same desperate letter, there is mention of a painting—*Te Arii Vahiné (The Noble Woman)*—which he considered "better than anything I've done to date." It is a transposition of two famous paintings: Cranach's *Diana Reclining* (of which Gauguin had a photograph),

Gauguin's only daughter, Aline, was his favorite. The *Cahier pour Aline*, a collection of intimate notes, was dedicated to her. News of her death worsened Gauguin's deep depression during the winter of 1897–8.

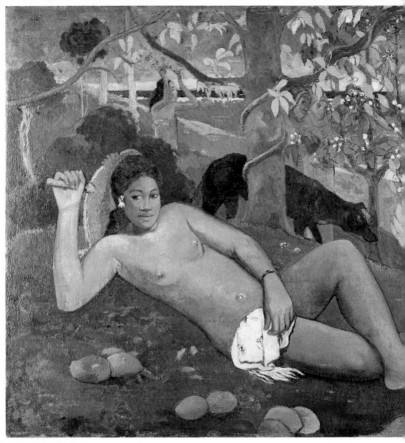

the basis for the figure's pose, her position in the landscape, and the tree; and, of course, Manet's *Olympia*, which he had copied in Paris when it entered the Musée du Luxembourg in 1891. From these European nudes, however, he created a large South Seas figure, a native queen separated from a lagoon by a delicate screen of foliage. The snake coiled around the tree trunk points to Gauguin's intent: to paint an Eve, but without implying original sin. "The Tahitian Eve is very subtle, very knowing in her naiveté. The enigma hidden deep in her

Te Arii Vahiné. "I've just done a big painting, 1 x 1.39 meters…: a naked queen reclining on a green rug.… I don't think I have ever done anything with such deep, resonant colors."

To Monfreid, April 1896

childlike eyes remains incommunicable to me."

Paradoxically, it was during these years of physical and psychological distress (1896–9) that Gauguin painted his largest, most paradisiacal compositions. They all include depictions of figures standing as they carry or pensively pick fruit, frozen in a gesture of prayer or offering, or seen through tree limbs as they advance on horseback; and they are all enveloped in lush tropical vegetation.

Their titles are eloquent: *Nave Nave Mahana (Delightful Day), Faa Iheihe (Tahitian Pastoral), The White Horse, Rupe Rupe (Luxury)*. "It is really life in the open, yet [an] intimate [life] all the same, among the thickets and secluded brooks; where women whisper in an immense palace decorated by nature herself with all the riches that Tahiti holds. Hence all these fabulous colors, this glowing but subdued and hushed air."

Jeanne Goupil, the youngest daughter of a wealthy Papeete lawyer, sat for *Vaïte Goupil*, one of the few portrait commissions Gauguin did for the colonial community in Tahiti.

"Where Do We Come From? What Are We? Where Are We Going?"

Despite the palpable majesty of its scenery and people, Tahiti was, for Gauguin, an imaginary Garden of Eden that existed only on canvas. In December 1897

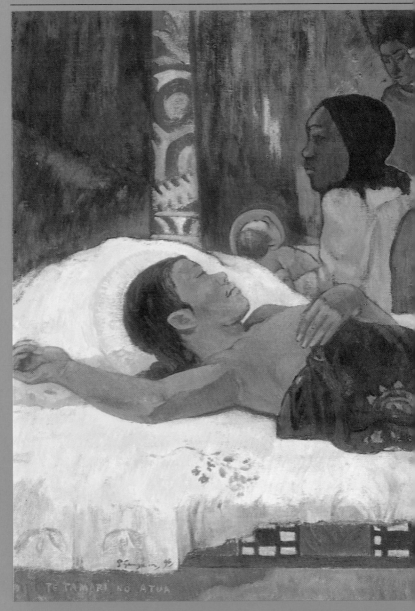

Pahura, Gauguin's young mistress at the time, gave birth to a daughter, who died shortly after birth. Thus *Te Tamari No Atua (The Child of God)* depicts not just the mother of a newborn child, but this particular Tahitian woman lying prostrate while a *tupapau*—the same one as in *Spirit of the Dead Watching*—holds the baby it is about to take away.

the artist was so desperate that he is believed to have contemplated suicide. First, however, he would paint his "last will and testament": It was to be the most famous of all the "Edenic friezes" and, about 14'9" in length, the most ambitious picture he had ever undertaken. Clearly Gauguin's intention was to take his place among the great decorative fresco painters he so admired, from the Renaissance to Puvis de Chavannes. In a letter to his friend Monfreid he recounted the circumstances surrounding the creation of *Where Do We Come From? What Are We? Where Are We Going?* "I must tell you that I had made up my mind [to commit suicide] during the month of December. So, before I died, I endeavored to paint a big picture I had in mind. I worked day and night that whole month in an incredible fever.… The appearance is terribly rough.… People will say it is slapdash, unfinished. True, no one is a good judge of one's own work; but I do believe not only that this painting is the best thing I have ever done, but that I'll never do anything better nor anything to approach it. Before dying I put into it all my energy, such aching intensity under appalling circumstances, a vision so clear, needing no correction, that the hurried execution disappears and it suddenly comes alive. The two upper corners are chrome yellow, with the inscription on the left, and my signature on the right, like a fresco with damaged corners on a golden wall." He goes on to describe the entire scene, which symbolizes the various stages and questionings of human destiny. "I think it's good," he concludes.

"A Certain Barbaric Luxury of Long Ago"

At this time Gauguin painted one of his most classic and most powerful nudes, one which echoes works by Ingres and Manet, whom he considered teachers. The title *Nevermore* may be interpreted as an allusion to Edgar Allan Poe's "The Raven" (which he knew through Mallarmé's translation) or as a nostalgic summing up of his life at the

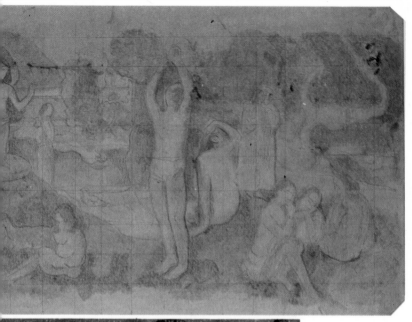

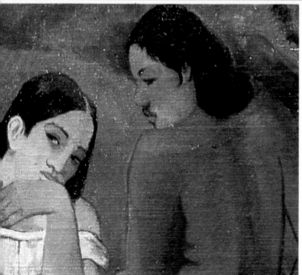

Sketch for *Where Do We Come From? What Are We? Where Are We Going?* squared on tracing paper and heightened with watercolor (above). Left: Details of the final oil version (see pp. 128–30), which includes the pensive women crouching at the lower right and the bird in the center.

time. This painting epitomizes the beauty of the primitive ideal Gauguin never really fulfilled; this body represents a life he could feel slipping away.

"I am struggling to finish a canvas to send with the others," he wrote to Monfreid, "but *will I have the time?*... I believe it's a good thing. I've tried to suggest, by means of a nude, a certain barbaric luxury of long ago. The whole [picture] is suffused with deliberately subdued

"As a title, *Nevermore*; not the raven of Edgar Poe, but the bird of the devil on the watch. It is badly painted...but no matter—I think it's a good painting."
To Monfreid,
14 February 1897

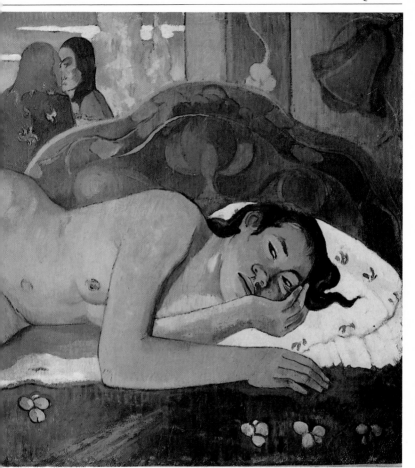

and sad colors. It is neither silk, nor velvet, nor cambric, nor gold that creates this luxury, but simply paint enriched by the artist's hand."

"The Fragrance of a Bygone Joy, Which I Breathe in the Here and Now"

The majesty of this nude, the sweep of his large-scale compositions, and the stifling splendor of *The White*

The Tahitian model of *Nevermore* ranks with the large classical nudes Gauguin admired so much, including Ingres' *Grandes Odalisques* and Manet's *Olympia*.

Horse and other landscapes from this period reflect on canvas what Gauguin was expressing at this time in his letters (which, as contemporary Symbolists pointed out, showed real literary ability). "Here, near my hut, in total silence, I muse on violent harmonies amid the intoxicating fragrances of nature. A delight enhanced by some indescribably sacred horror I divine [beyond memory. The fragrance of a bygone joy, which I breathe] in the here and now. Animal figures, as rigid as statues: something indescribably ancient, august, and religious in the rhythm of their pose, in their singular immobility." Another example: "I can sense the plaintive progression of my hopes" (to Fontainas, March 1899).

Drawing of a monkey riding a pig, from *Les Guêpes (The Wasps)*, a satirical journal for which Gauguin supplied articles and illustrations (below). Below right: Transfer drawing for the front cover of the manuscript of *L'Esprit Moderne et le Catholicisme*, in which Gauguin inveighed against the contemporary Church and the decline of its evangelical spirit.

Gauguin the Muckraker

Poverty-stricken and in poor health, Gauguin did very little painting in 1899 and 1900. "As I am very ill and compelled to work at mindless jobs to earn a little money, I no longer paint except on Sundays and holidays," he wrote to Maurice Denis, a young admirer in Paris who had asked him to exhibit with the Nabis. He was particularly galled when he learned that a group of paintings he had shipped to Vollard—*Where Do We Come From?...* and eight others—had been sold for the ridiculously low sum of 1000 francs.

Les Guêpes

He performed various odd jobs to make ends meet and took up local journalism with something of a passion. He wrote for *Les Guêpes (The Wasps)*, a satirical paper, and became its editor in chief; he then started and, for a time, illustrated another, *Le Sourire (The Smile)*. His intentions were not altogether clear-cut. Some excerpts could place him in the tradition of libertarian polemists, but by and large he stood up for the interests of the local Catholic clique and defended "poor whites" against the Chinese business "lobby" in Tahiti. On 23 September 1900 he even

Gaspard et son petit Page

Si le petit Page pouvait!
Si Gaspard savait!

delivered a memorable speech on behalf of the Catholic Party, in which he alluded to "this yellow blot on our country's flag." Those wishing to make Gauguin out to be a standard-bearer of anticolonialism and cultural ecumenism (which, as we shall soon see, he proved to be in the Marquesas) will find his virulence disquieting.

But, as we have seen time and again, Gauguin was a complex, at times self-contradictory man: modern, yet classical; proud and nonconformist, but eager for recognition; a lover of "the primitive," but up to a certain point; a savage and a Parisian rolled into one. In short, an exile wherever he went.

Self-portrait dedicated to Daniel de Monfreid.

Another Departure: "The Public Was Getting Too Accustomed to Tahiti"

From Paris came the wherewithal to start painting again and to leave Tahiti and its time-consuming local political scene. At long last Vollard offered him a monthly salary of 300 francs in return for a certain number of paintings a year. Gauguin had been waiting for a financial arrangement such as this for a decade.

Finally Gauguin was in a position to start planning his next departure. "With entirely new and primitive sources of inspiration, I shall do fine things. My imagination was beginning to flag here, and, besides, the public was getting too accustomed to Tahiti, which has become 'comprehensible and charming.' My paintings of Brittany are now like so much rose-water because of Tahiti; Tahiti will become so much eau de cologne after the Marquesas."

G auguin's "House of Pleasure" in the Marquesas Islands, as sketched by a neighbor.

Primitiveness held out the promise of a new lease on life. "I am laid low these days, defeated by poverty and especially the disease of a premature old age. Shall I have some respite to finish my work?… In any event, I am making one last effort by moving next month to Fatu-iva, a still almost cannibalistic island in the Marquesas. There, I feel, completely uncivilized surroundings and total solitude will revive in me, before I die, a last spark of enthusiasm which will rekindle my imagination and bring my talent to its conclusion."

The Marquesas: Hiva Oa

As it turned out Gauguin moved to Atuona on the island of Hiva Oa (then called Dominique), "certainly the most civilized place in the Marquesan archipelago" (Danielsson). His first contact with the island was not without its surprises. Upon his arrival on 16 September 1901 Gauguin received a triumphant welcome from the local "poor whites," who, based upon his stinging

attacks on the government and the Chinese in *Les Guêpes*, looked to him as their champion against the central administration.

Yet, in spite of everything, he took one final plunge into semi-native life and productive isolation. He took in a girl as his mistress and built a comfortable hut, the celebrated House of Pleasure. The inscription *Maison de*

These carved panels from Gauguin's "House of Pleasure" once framed the entrance leading directly to the bedroom at the top of the stairs. Several motifs already seen in Gauguin's work reappear on these polychrome reliefs: For example, the base panels *Be Mysterious* and *Be In Love and You Will Be Happy* echo sculpture done in Brittany ten years earlier.

Jouir on the lintel of his carved door frame was intended both to proclaim a life-style and to nettle the Catholic missionaries who tried to prevent him from leading schoolgirls "astray."

In the remaining eighteen months of his life Gauguin painted, wrote, drew, and sculpted at a relatively prolific pace, considering his state of health and the time he devoted to local affairs. He defended a group of Marquesan natives in court against the administration and spent considerable time feuding with members of the Catholic mission. In 1902 he painted his superb last pictures, which were rapidly executed, more simplified than the Tahitian work, and generally stripped of all primitivist allegory, Polynesian titles, and other

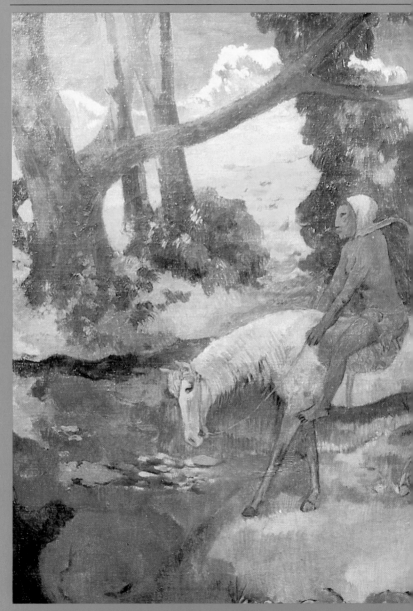

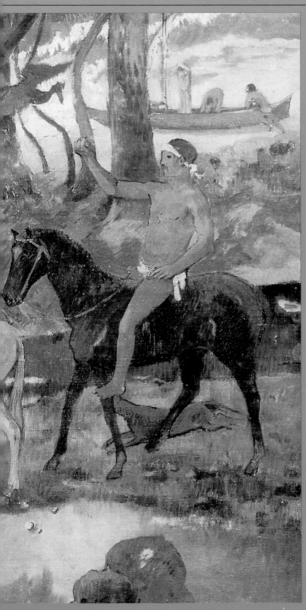

The Painter of the Marquesas

The Riders or *The Ford* (1901) was probably inspired by Dürer's *Knight, Death, and the Devil* (a reproduction of which Gauguin had glued to the back cover of his *Avant et Après* manuscript). Could the lead rider wearing a pink hood be a *tupapau?* In any event, the darkened area the riders are passing through, the screen of trunks and branches, and the dazzling beach and sea beyond all conspire to create a scene that is both splendid and mysterious.

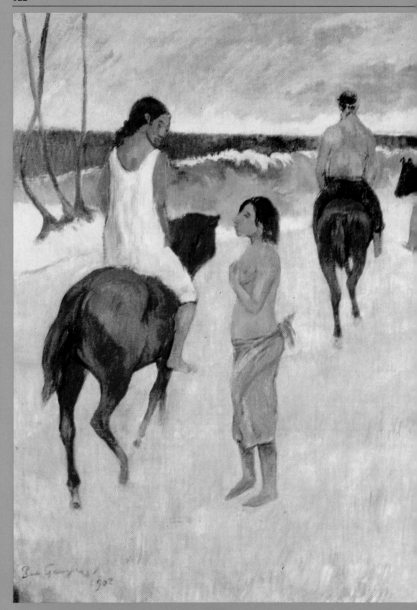

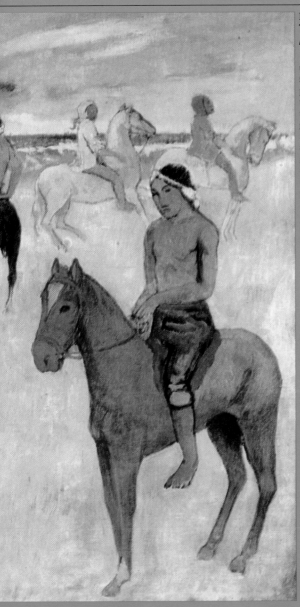

Racetracks in the Tropics

These *Riders on the Beach* (1902) seem to be the same as the ones from the preceding picture. Having forded the stream and made their way through the gloomy, dense growth into the realm of light and color, they are free to gallop on the pink sand as the ocean billows in the distance. Even transplanted to the tropics, the scene recalls Degas' *Racetrack* pictures and testifies to his enduring effect on Gauguin.

This *Still Life with Sunflowers* dates from 1901, shortly before Gauguin left Tahiti. Two years earlier he had asked Daniel de Monfreid to send him some seeds for his garden, including seeds for sunflowers, unknown in Tahiti at the time. Could he have been reminiscing about Vincent van Gogh?

folkloric embellishment: *Woman with a Fan, Riders on the Beach, And the Gold of their Body, The Call, The Riders.* These masterpieces of formal simplicity and vividly colored energy bear out Gauguin's rapturous statement: "Here poetry wells up of itself, and one has only to drift into dreaming as one paints in order to suggest it."

"We Created Freedom in the Plastic Arts"

Although Gauguin did not suspect he had so little time left, he took stock of his lifework in various writings or letters the year before he died. "I feel I have been right about art… and if my works do not endure, there will remain the memory of an artist who set painting free." Elsewhere: "I am a savage. And civilized people sense it. There is nothing surprising or baffling in my work except for that 'savage-in-spite-of-myself' quality. That is why [my work] is inimitable."

Yet, shortly before he died of an apparent heart attack on 8 May 1903—a castle-builder to the end—he dreamed of returning to Europe to seek medical treatment and fresh sources of inspiration. Another archaic exoticism awaited him in Spain, or so he believed. It is tempting to imagine what

Tohotaua, a beautiful red-headed Marquesan woman, was the model for *Woman with a Fan.* Below: A photograph of Tohotaua posing in Gauguin's studio.

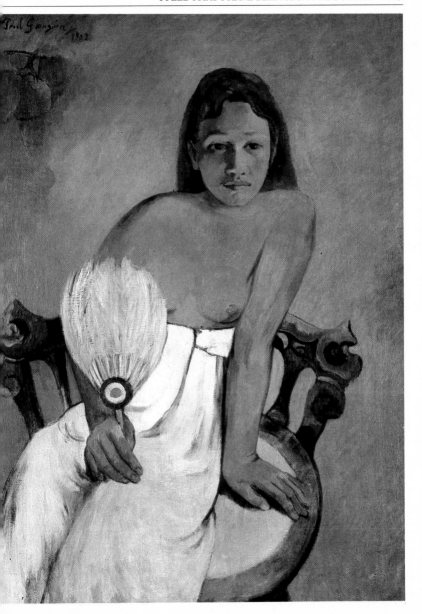

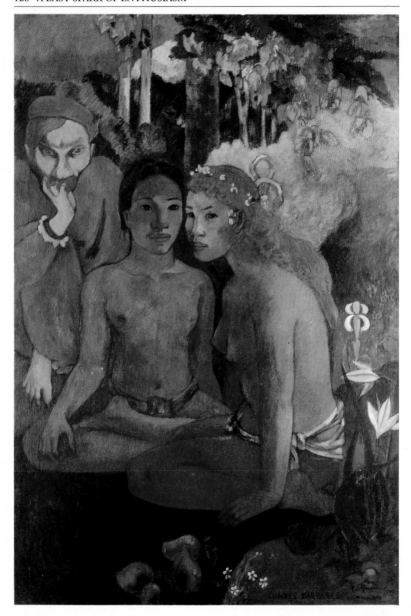

might have come of a meeting between the aged Gauguin and young Pablo Picasso at Cadaqués the summer before *Les Demoiselles d'Avignon*.

A month before he died he wrote these proud, heart-rending words to Charles Morice: "Solitude should not be recommended to everyone; you've got to have the stamina to withstand it and act on your own." The texts he drafted at this time (*Avant et Après, Racontars de Rapin*) paint a picture of a man all alone, a sometime alcoholic and an inveterate skirt-chaser, an aging "hippie" whose provocative gibes and hairsplitting arguments cannot mask either his courage beneath the despair—"I had the willpower to do things my way"—or his absolute confidence in art.

In his self-exile, his final deprivation, he achieved true nobility; and history bore out his last writings from the Pacific, which he cast, like so many messages in a bottle, into the sea of time and space. If one stops to consider his influence on such later artists as Bonnard, Matisse, or Picasso, his point that the younger painters "owe me something" was well taken.

In his last text, *Racontars de Rapin*, his own artistic destiny, as well as the destiny of those contemporary painters he respected, took their place in the history of modern thought. Our hero of the "exile to savagery" made his final exit on a note of patriotic pride: "That, to my mind, is consolation enough for the loss of two provinces, for with that we conquered the whole of Europe and, especially of late, created freedom in the plastic arts. Hail and farewell. Paul Gauguin."

One of Gauguin's last brilliant studies of South Seas nudes, *Contes Barbares (Primitive Tales)*, 1902, seems to sum up all the mythologies dear to his heart: Polynesian, Asiatic, Judeo-Christian. Below: A poignant self-portrait of the farsighted, ailing Gauguin shortly before his death.

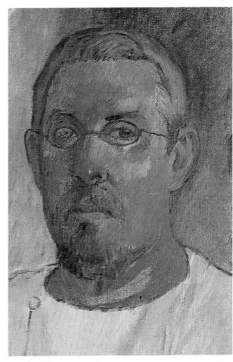

Where Do We Come From? What Are We? Where Are We Going? is Gauguin's largest and most famous painting. According to the artist it was done "straight off onto sackcloth full of knots and wrinkles, so it has a terribly rough appearance."

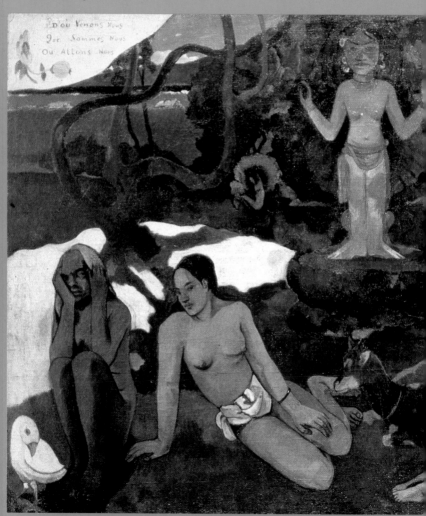

"At the bottom right is a sleeping baby, then three crouching women. Two figures dressed in purple are sharing their thoughts; a crouching figure, intentionally oversized in defiance of perspective, lifts its arm in amazement at these two who dare to ponder their destiny. A central figure picking fruit. Two cats next to a child. A white she-goat. The idol, both arms uplifted in a mysterious rhythmical pose, seems to indicate the world to come. The seated figure seems to be listening to the idol; and lastly comes an old woman, near death and seemingly resigned to her thoughts. She completes the story. At her feet a strange white bird with a lizard in its claws

represents the futility of empty words. All this in a woodland setting by a stream. Despite tonal transitions the landscape is uniformly blue and Veronese green from one end to the other, and the naked figures stand out against it in bold orange."

To Monfreid,
February 1898

DOCUMENTS

Gauguin Through His Writings
Gauguin as Seen by His Critics, Colleagues, and Friends
Gauguin and His Moods

Selected Correspondence

A sampling of Gauguin's most significant or touching letters to his wife and friends. Like everything he wrote, whether published or personal, they show that the artist possessed a great literary talent.

TO EMILE SCHUFFENECKER

[Copenhagen] 14 January 1885

My dear Schuffenecker,

Received a letter from Guillaumin. It seems you wanted to buy one of his pictures at the exhibition, but it was already spoken for. Why don't you go to him and pick out another? I think you'll be glad to have a work of his, and, besides, I'd like to see this poor but highly talented artist get the sale.

As for myself, sometimes I think I'm going mad, and yet, the more I lie awake nights in bed thinking things over, the more I think I am right. For a long time, philosophers have been rationalizing the phenomena that seem supernatural to us, yet which we are able to *sense*. Everything is in that one word. The Raphaels and others were people in whom sensation was formulated long before thought, which allowed them, even while they were studying, to help keep that sensation forever intact and to remain artists. As I see it, a great artist is the most intelligent of formulators; he

receives the most delicate and, consequently, most invisible feelings or translations of the mind.

Look at nature's immense creation and see if there aren't laws—varying in their aspects, yet similar in their effect —that generate all human feelings. Look at a great big spider, or a tree trunk in a forest: Both give rise to a terrible sensation within you without your even realizing it. Why do you

find it so disgusting to touch a rat and so many other things like that? You cannot argue these feelings away. All our five senses reach *the brain directly* stamped by an infinity of things that no amount of learning can destroy. From this I conclude that some lines are noble, other deceptive, and so forth. A straight line reaches to infinity; a curve limits creation; not to mention the fatality of numbers. Has enough been said about the numbers 3 and 7? Colors, although less numerous, are even more explicative than lines because of their power over the eye. Some colors are noble, others commonplace; some harmonies are peaceful and comforting, others thrill you with their boldness. Through graphology you can tell the features of a sincere man from those of a liar; why shouldn't lines and colors also reveal how much grandiosity there is in an artist's temperament? Look at Cézanne the Misunderstood: an essentially mystical, Oriental temperament (his face looks like an old man from the Levant). He is partial to forms that exude the mystery and tranquility of a recumbent man dreaming. His somber colors are in keeping with the Oriental frame of mind. A man of the Midi, he spends entire days on mountaintops reading Virgil and gazing at the sky. Thus, his horizons are very high, his blues very intense, his reds stunningly vibrant.

Like Virgil, who has more than one meaning and can be interpreted as one likes, the literature of his paintings has a parabolic, twofold meaning. His backgrounds are as imaginative as they are real. To sum up: When you look at one of his paintings, you exclaim, "Strange!" But he's a mystic, likewise his *drawing*.

The farther I go in this matter, the more I tend to favor translations of thought for something altogether different than a literature. We'll see who is right. If I'm wrong, then why doesn't all your Academy, which knows all the methods the old masters used, turn out masterworks of its own? Because you can create a composition but not a temperament, a mind, or a heart. Young Raphael intuited this, and in his pictures there are harmonies of line you cannot account for, because they are the veiled reflection of man's innermost being. Look at even the props, the natural setting in a Raphael, they'll convey the same feeling as a head. Purity through and through. A landscape by Carolus Durand is as *raffish* as a portrait. (I cannot tell you why, but that's the feeling I get.)

Here, I am tormented by art more than ever, and neither my money worries nor my business pursuits can take my mind off it. You tell me I'd do well to join your Society of Independents. Shall I tell you what would happen? Today you are a hundred strong; tomorrow there'll be two hundred of you. Conniving tradesmen-artists make up two-thirds, and before you know it Gervex and others [like him] will have come to the fore, and then what shall we, the dreamers, the unappreciated, do? This year you've gotten *favorable press*; next year (there are Raphaelis everywhere), they'll stir up all the mud and sling it at you to make themselves look respectable.

Keep on working *freely* and *furiously*. You'll make progress and, sooner or later, your worth, if you have any, will be recognized. Above all, don't sweat over a picture. A strong emotion can be translated immediately; dream on it and seek its simplest form.

"The equilateral triangle is the sturdiest and most perfect of triangles. A long triangle is more elegant. In pure truth, there are no sides; we say, lines to the right advance, those to the left retreat. The right hand strikes, the left protects. A long neck is graceful, whereas heads directly on shoulders are more pensive"—and heaven knows what else. Why not "A duck with its eyes above water is listening"—it's all a lot of idiotic rubbish. Your friend Courtois may be more reasonable, but his painting is so stupid. Why are willows with hanging branches called weeping? Because drooping lines are sad? And are sycamores sad because they're found in cemeteries? No, it's the color that's sad.

Businesswise I am still at square one. I won't see any results, if there are any, for another 6 months. Meanwhile, I am penniless, in a real fix. That's why I console myself with dreams.

Gradually we'll muddle through. My wife and I are giving French lessons. Can't you just see it—me, giving French lessons!

May your luck be better than ours. Regards to your wife.

TO HIS WIFE

Gauguin, Painter
c/o Mme Gloanec
Pont-Aven (Finistère)
 [*Pont-Aven, late June 1886*]

My dear Mette,

I managed to scrape together the money for my trip to Brittany, and I'm living here on credit. Hardly any Frenchmen; all foreigners. One man and 2 women from Denmark, Hagborg's brother, and lots of Americans. My painting is sparking considerable discussion and, I must say, is being fairly well received by the Americans. That is some hope for the *future*. Yes, I'm doing lots of sketches, and you'd hardly recognize my painting. I hope to keep my head above water this season; if you get a little money from Le Monet, would you send it to me? What a pity we didn't make Brittany our home earlier on; we're paying 65 francs a month at the hotel for room and board. The food fattens you up as you eat it. There's also a house available for 800 francs with stable, coach house, studio, and garden. I'm sure that a family could live quite happily on 300 francs a month.

You imagine we're isolated. Not in the least. There are painters [here]

winter and summer, Englishmen, Americans, etc. Later on if my pictures generate a modest but continuous cash flow I can count on, I'll set up shop here year round.

In your last letter, you mentioned being sick in bed, but you didn't tell me what was ailing you. You mustn't let youself get run down like that. What would you do without a roof over your head? Everything's relative in this world, and you should consider yourself fortunate compared to other people. Emil is on vacation having fun; the others are in the country. My little Clovis is spending his vacation in a *pension*; I couldn't bring him along. Let's hope next winter will be better. At any rate, I'll be less undecided. I'd rather do away with myself than live the way I did last winter, by begging.

I'll rent a little studio near the Vaugirard church, and there I'll work at modeling ceramic pots the way Aubé used to do. Monsieur Bracquemond, who has befriended me because of my talent, is getting me into this line of business and told me that it could *turn into* something lucrative.

Let's hope I have as much of a gift for sculpture as I do for painting, which I'll pursue at the same time.

Kiss the children for me.

If you can get a photo taken of little Aline, send it to me.

TO HIS WIFE

[*Saint-Pierre*] *20 June 1887*

My dear Mette,

This time I'm writing to you from Martinique; I had planned on coming here much later. For quite some time

Martinique Pastorals, from the *Volpini Suite*, 1889.

Mette Gauguin in Copenhagen.

now, bad luck's been against me and preventing me from doing what I wanted to do. I'd been working for the [Panama Canal] Company for 2 weeks when orders from Paris came to suspend much of the work, and they dismissed 90 employees in a single day, and so forth. Of course, as a newcomer, I was among those on the list. I packed my trunk and headed here. Good thing, too. Laval had just come down with a bout of yellow fever which, fortunately, I cut short with homeopathy. So, all's well that ends well.

For the time being we are living in a Negro shack, and it is paradise compared to the isthmus. Below us, the sea, fringed with coconut palms; above, fruit trees of every variety, and all 25 minutes from town. Negro men and women mill about all day long with their Creole songs and ceaseless chatter. Don't think it's monotonous; on the contrary, it's quite varied. I cannot tell

you how enthusiastic I am about life in the French colonies, and I'm sure you'd feel the same. Nature at its lushest, a warm climate but with cool spells. It doesn't take much money to make a person happy here, but one does need a certain amount. Case in point: right now, for *thirty thousand* francs, one could buy a piece of property that'd bring in 8 to 10 thousand francs a year and what's more, live off the fat of the land. The only work would be supervising a few Negroes while they pick fruit and vegetables, which need no cultivation.

We've begun working and in a while I hope to send out some interesting pictures. At any rate, we'll be needing a little money a few months from now. That's the only dark cloud on the horizon. I'd like to hear from you, and with all these changes I haven't received any letters yet.

Another 7 June came and went, and not a single word from anyone about it. Some birthday!

I can tell you that it's not easy for a white man to hold on to his virtue here, for Potiphar's wives are not lacking. Nearly all of them are dark-complexioned, from ebony to dusky white. They go so far as to bewitch fruit, which they then offer to ensnare you. The day before yesterday, a young Negress of 16—damned pretty, too— offered me a guava that was split open and squeezed at the tip. The girl left and I was about to eat it when a sallow lawyer who happened to be there snatched the fruit from my hands and threw it away. "You, sir, are a European," he said. "You are not familiar with the customs here. You mustn't eat fruit unless you know where it comes from. This piece, for example,

has a spell cast over it. The Negress crushed it against her bosom; surely she would have had her way with you later on." I thought he was pulling my leg. Nothing of the kind. This wretched mulatto—an educated man, too—believed in what he said. Now that I've been forewarned I shan't go astray, and you can rest easy about my virtue.

I really hope to see you here one day with the children. Don't fly off the handle: There are schools in Martinique, and white people, being exceedingly rare, are treasured.

Write twice a month.

You can't say I've written a nasty letter.

TO HIS WIFE

[*Le Pouldu, late June 1889*]
My dear Mette,

That's right, you haven't heard from me in over 6 months; but it's been more than 6 months since I've had news of the children. It seems there has to be a serious accident before I do—hardly cause for celebration even if [he is] completely out of danger (or so you say).

You never can tell: A thing like that could turn a person into a cripple or an idiot, only it wouldn't begin to show until much later. Anyhow, I am so inured to adversity.

Do you realize how many times I've written and my letter crossed yours, and because you're the last to write you play at silence? Whether I write or not, doesn't your conscience tell you that every month I must have news of the children I haven't seen for 5 years—and yet, you remind me that I'm their father every chance you get.

There was a possibility of my going to see them over six months ago (spur of the moment), but you Copenhagen people decided that it wasn't worth the

*T*he *Joys of Brittany*, from the *Volpini Suite*, 1889.

expense. Reasons of the pocketbook are always taken into consideration; reasons of the heart, never. Poor woman—to let yourself be *so poorly advised*, and by people so unwilling to part with their pennies—or their pride. What about all the money that's *wasted when partners don't see eye to eye?* That's something you'll never understand. What do you expect of me? What have you expected of me most of all? In the Indies, wherever, that I should be a beast of burden, and for whom, for a wife and children *I must not see*. For the sacrifices I've made, this homeless existence, this deprivation, what do I get in return—I am to be *loved if I love, written to* if I write, and so on. You know me. Either I calculate (and I do it well) or I don't; open-handed, eyes front, breast bared— that's how I fight. Your powerful sister has not yet abdicated her authority over you; but in return where is her support?

Very well, then, say I accept the role that's been assigned to me. Now I have to calculate and not take the substance for the shadow—the shadow being the role of employee. If I were earning 2000 or 4000 francs—your brothers' figures—what could anyone reproach me for, nothing, and yet both of us would be pretty much in the same predicament. No one ever gives a thought to the future.

Despite the confidence my conscience gave me, I resolved to consult others (people who also count) to make certain I was doing my duty. They all thought as I did, that art is my business, my capital, the future of my children, the honor of the name I've given them—all of which will be of use to them one day. When the time comes for them to make their way in the world, an honorable father *everybody's heard of* may stand them in good stead. Consequently, I am working away at my art, which may be of no account (moneywise) for the time being (times being hard) but promises to be in the future.

That's a long way off, you'll say. But what do you want me to do about it? Is it my fault? I am the first to suffer from it. I can assure you that if people who know about such things said that I didn't have any talent and that I was an idler, I'd have packed it all in long ago. Can it be said that Millet failed in his duty and bequeathed a wretched future to his children?

Want to know what's new with me?

I am at the seashore, in a fishermen's inn, near a village of 150 inhabitants. I'm living here like a peasant under the name of Savage. I've been working every day in canvas trousers (all the ones from 5 years ago are worn out). I spend 1 franc a day on food and 2 on tobacco, so I can't be accused of living high on the hog. I speak to no one, and I'm not getting any news of the children. Alone—all alone—I'm exhibiting my work at Goupil's in Paris. It is creating quite a stir, but proving very difficult to sell. When that will happen I cannot say, but what I can tell you is that today I am one of the most astonishing artists around. Enclosed a few lines about me. You exhibited some old things of mine in Copenhagen; you might have consulted me first.

7 June 1889 came and went, and not one of the children remembered. Anyhow, all's well that ends well. I'm putting out feelers through influential friends of mine about a position in Tonkin. I intend to live there a while and wait for better times. Since such jobs are paid for, you might get some pictures sold at Goupil's, not all of

B*reton Women by a Fence*, from the *Volpini Suite*, 1889.

them, mind you. For the time being, I have nothing. I am expecting a wood carving to sell (probably). As soon as it does I'll send you 300 francs—you can count on it. It's just a matter of time. And I'm writing to Paris to push it through.

This year I exhibited work in a *café chantant* at the Paris World's Fair. Perhaps some Danes saw it and mentioned it to you. At any rate, nearly all of the Norwegians have been to Goupil's to see what I'm doing, and Philipsen, whom I ran into in Paris, has seen them, too.

Once and for all, do not end your letters with that dry phrase "Your wife, Mette." I'd rather you come right out and say what's on your mind. I've spoken to you about this before, but you've refused to understand.

Le Pouldu, near Quimperlé
(Finistère)

TO VINCENT VAN GOGH

Le Pouldu [20 October 1889]

My dear Vincent,

My reply to your long letter is long overdue. I know how isolated you are in Provence and that you like hearing from friends who interest you, but circumstances have prevented me from doing so. Among other things, a rather big project that de Haan and I took on together: decorating the inn where we take our meals. We started out with one wall and ended up doing all four, even the leaded glass window. It's very instructive, hence, useful. De Haan did a big panel 2 meters by 1.50 meters high right on the plaster. Enclosed you'll find a quick sketch I did of it. Local peasant women working on hemp with haystacks in the background. I think it's very good and very complete, executed as seriously as a painting.

I did a peasant woman scurrying along the seashore, followed by her dog and cow. Both our portraits on every door. I worked feverishly and couldn't wait to see the whole thing finished; before I knew it, it was time to retire and I put off writing you till later. Now let's you and I talk.

I've done only one religious picture this year. It's advisable to *try out* all kinds of things from time to time to keep one's powers of imagination alive, and afterward one looks at nature with fresh delight. Anyhow, it's a question of temperament.

What I've concentrated on this year is simply peasant children strolling unconcernedly along the shore with their cows. Only, since I don't care for the trompe l'oeil of alfresco painting or what have you, I'm trying to put into these dreary figures the wildness I see in them, which is in me, too. There is something medieval looking about the peasants here in Brittany; they don't look as though they suspect for a moment that Paris exists or that it's 1889. Just the opposite of the Midi. Here everything is as rugged as the Breton language, closed tight (forever, it seems). Their apparel, too, is little short of symbolic, influenced by the superstitions of Catholicism. Look at how the bodice forms a cross in back, how they wrap their heads in black headscarves, like nuns. It makes their faces look almost Asiatic—sallow, triangular, dour.

Hang it all—I want to take stock of nature, too, but not at the expense of what I see in it, of what reaches my mind. The rocks are black and yellow; so is what they wear; surely I can't depict them as flaxen and coquettish. Still fearful of the Lord and of the parish priest, Bretons hold their hats and tools as though they were in church. That's how I paint them, not full of southern zest.

Right now I'm doing a 50 canvas: some women gathering seaweed by the seashore. They look like boxes tiered at intervals, dressed in blue clothes and black headdresses despite the bitter cold. This compost they gather to fertilize their land is ocher-colored with tawny glints. *Pink* sand, not yellow, probably because of the damp— somber sea. As I look at this every day, I suddenly sense the struggle to survive, a sadness, a submission to wretched laws [of nature]. I am trying to capture that on canvas, not at random, but rationally, perhaps also exaggerating that certain stiffness in their poses, certain dark colors, etc. It all may be *mannered*, but what is there in a painting that's natural? Since earliest times *everything* has been in pictures, thoroughly conventional, intentional, from beginning to end. Far from natural, hence, very mannered. The old masters had genius, you'll say. That's right, and we don't, but that's no reason not to proceed as they did. To a Japanese, what we do is mannered, and vice-versa. That's because there is a significant gap in the way we look at things, our customs, what we consider typical. Therefore, if extraction, temperament, or some other factor causes a man to see, feel, think differently from the common herd, he is affected and, consequently, mannered.

You've seen the portal of Saint-Trophime in Arles, in vision and execution so different from what Northerners do, with *proportions* that are anything but natural, and you've

admired it without nightmares—not as art. (The truth is what a person feels in his state of mind at the time.) Those willing and able to dream do so. So do those willing and able to shed their inhibitions. In nature, dreams always come from reality. An Indian savage will never see in his dreams a man in Parisian-style clothes, etc.

De Haan is still working in Le

Emile Bernard.

Pouldu, thanks you for so kindly remembering him, and sends you his best. He is the (sole) creator of Uriel, the picture you discussed in a letter to Isaacson. I haven't gotten your sketch after Rembrandt, the one you suggested as part of an exchange (which I'll gladly do).

A hearty handshake.

TO EMILE BERNARD

Le Pouldu, 1890

My dear Bernard,

Thank you for your fine, friendly letter. Yes, I am distressed and that's why I held off writing back. All these things are close to my heart and affect me more than I can say despite all the trouble I've taken to harden my heart. As for the cliques that rant and rave in

Breton cupboard carved and painted by Emile Bernard and Paul Gauguin (1888).

front of my pictures, that doesn't bother me very much, especially since I myself know they are imperfect, rather, an approximation. Sacrifices must be made in art, from one period to the next, with concomitant trial runs, a floating idea without direct or definitive expression. What, touch the heavens for just a fleeting minute? But on the other hand,

this *glimpse* of dream is more powerful than anything material. Yes, we artists, we seekers and thinkers, are destined to succumb to the blows the world deals us, but succumb in a material sense. Stone decays; words endure. We're in a real fix, but we're still not done for. I'll save my skin yet. If I can get what I'm looking for, a decent job in Tonkin, I'll be able to work on my painting and save money. The entire East—the lofty thoughts inscribed in golden letters in all their art—all of that is worth studying, and I feel I can revitalize myself out there. The West is effete at present, and even a [man with the strength of] Hercules can, like Antaeus, gain new vigor just by touching the ground [of the Orient]. A year or two later you come back robust.

I am recovering just now, weary but not exhausted. There's not much light during the day, so I relax by carving and doing still lifes. It has been storming for ten days, the sea is scouring the beach, and with no news from Paris it is all quite bleak at the moment.

The purchase of *Olympia* strikes me as very funny now that the artist is dead. Will the Louvre take it? I think not but *hope they do.*

Because the wind is howling and since that would be an appeasement, it would be better for the deluge to grow to colossal proportions, then they'll have no choice but to pay through the nose for *Olympia*, as they did for the Millet. Right now, the more stupidity there is, the clearer the signs of better times on the horizon, and you who are young will live to see this. As for doing an article on the subject, I am hardly encouraged by the reception given the one I wrote this year. I wrote Aurier two letters and he *hasn't written back*, the lousy good-

for-nothing. *Le Moderniste* didn't come, so I haven't had the chance to read him, the *Devil.*

I smiled when I saw your sister looking at my pot. Confidentially, I rather intended to test the extent of her admiration for this medium. I was planning to give her one of my best efforts, even though it didn't turn out all that well (in the firing).

You've known for a long time—and I've written so in *Le Moderniste*—that I look for character in every medium. Well, the character of gray pottery is the feeling of a high fire, and this figure scorched in the inferno expresses this quality pretty forcefully, I think. Like an artist Dante might have caught a glimpse of during his visit to Hell.

A poor devil, all curled up to endure his suffering. Be that as it may, the prettiest girl on earth cannot give more than what she has.

Vincent wrote me roughly what he did you: that we were heading toward Mannerism, etc. I wrote him back!

Oh, yes—I have a favor to ask of you. Could you have a photograph taken of the pot against a light background and well illuminated to bring out the glints of color on the surface.

A warm handshake.

I apologize to Madeleine for the coarseness of her pot.

TO ANDRE FONTAINAS

Tahiti, March 1899

Un grand sommeil noir
Tombe sur ma vie;
Dormez, tout espoir,
Dormez, toute envie.

Verlaine

Monsieur Fontainas,

Mercure de France, January issue, two

interesting articles: Rembrandt. Galerie Vollard. The latter involves me. Despite your aversion, you tried to examine the art or rather the work of an artist who does not move you, and to talk about him with fairness. A highly unusual thing in a critic.

I have always felt that it was a painter's duty never to answer even harmful criticism—above all that kind—or, for that matter, laudatory criticism, which is often prompted by friendship.

Without relinquishing my customary reticence, for once I have this irrational longing to write to you, a caprice if you will, and—like all passionate men—I'm finding it hard not to give in. This is not a reply, as it is personal—just a chat about art, at the bidding, at the prompting of your article.

We painters, those of us condemned to poverty, accept the woes of material existence uncomplainingly, but we do suffer from them insofar as they get in the way of our work. All that time wasted seeking our daily bread! Menial, mindless jobs, defective studios, countless other impediments. This leads to discouragement, then to helplessness, rage, violence. Considerations you are all too aware of and which I mention only to convince us both that you are right to point out a great many shortcomings. Violence, monotony of tone, arbitrary colors, etc.—yes, it's all probably there; it *is* there. Sometimes, however, those repetitions of tone, those monotonous harmonies, in the musical sense of the word, are deliberate. Aren't they analogous to those Eastern chants sung by shrill voices and accompanied by resonant notes that are close to them, yet with enough contrast to have an enriching

effect? Beethoven makes frequent use of them (if I've understood him correctly)—in the Pathétique Sonata, for example. Delacroix, with his repeated harmonies of muted chestnut and violet, a dark mantle hinting at drama. You often to go the Louvre: Think about what I'm saying as you take a good close look at Cimabue. Think, too, about the musical role color will assume from now on in modern painting. Color is vibration, the same as music, and is capable of capturing what is most general and, therefore, most elusive in nature: its inner power.

Here, near my hut, in total silence, I muse on violent harmonies amid the intoxicating fragrances of nature. A delight enhanced by some indescribably sacred horror I divine, beyond memory. The fragrance of a bygone joy I breathe in the here and now. Animal figures, as rigid as statues: something indescribably ancient, august, religious in the rhythm of their pose, in their singular immobility. In dreaming eyes, the blurred surface of an unfathomable riddle.

Then night comes on—all is at rest. My eyes close, to *see without comprehending* the dream in the infinite space before me, and I can sense the plaintive progression of my hopes. Praising certain pictures I considered unimportant, you exclaimed, "Oh, if Gauguin were always like that!" But I don't want to be always like that.

"In the broad panel Gauguin is exhibiting, nothing seems to reveal the meaning of the allegory to us."…Yes, my dream defies comprehension, it involves no allegory: A musical poem, it needs no libretto (quote from Mallarmé). Immaterial and transcendent, the essence of a work of

art lies precisely in "that which is not expressed: the implicit result being lines, without colors or words, which do not enter materially into its makeup."

Mallarmé also said while looking at my Tahitian pictures: "It is extraordinary that so much mystery can be put into so much brilliance."

To come back to the panel. The idol is there, not as a literary explanation, but as a statue, less of a statue, perhaps, than the animal figures; less of an animal, too, fusing—in my dream, in front of my hut—into the whole of nature, reigning in *our primitive soul*, imaginary consolation for the suffering caused by our inability to plumb the mystery of our origin and our future.

And all that was singing mournfully in my soul and my surroundings as I painted and dreamed all at once, and no comprehensible allegory within my reach—lack of a literary education, perhaps.

Upon awakening, my dream-painting finished, *I said to myself, I said*: Where do we come from? What are we? Where are we going? Thoughts that are no longer part of the canvas, but quite separately inscribed in spoken language on the wall which frames, not a title, but a signature.

You see, I've tried, without success, to understand the meaning of words— abstract or concrete—in the dictionary; I no longer grasp them in painting. I have tried, in an evocative setting, to translate my dream without resorting to literary expedients, with all the simplicity my craft is capable of—hard, hard work. Accuse me of having been ineffective in that regard, but not of having made the effort, advising me to switch goals and linger over other ideas that have already been accepted and

hallowed. Puvis de Chavannes is the supreme example of this. Yes, indeed, Puvis overwhelms me with his talent, and the experience I lack; I admire him as much as and even more than you do, but for different reasons. (Don't take offense; I know better than you whereof I speak.) To each his era.

The government is right not to commission me to decorate any public buildings, for such decoration would clash with the thinking of the majority, and, besides, it would be wrong of me to accept and then have no alternative but to cheat or be false to myself.

At my exhibition at Durand-Ruel's, a young man asked Degas to explain my pictures, as he didn't understand them. Degas smiled and told him a fable from La Fontaine. "Don't you see," he said. "Gauguin is the starving Wolf, without the collar."

It's taken fifteen years of struggling to finally emancipate us from the Ecole, from that hodgepodge of formulas without which there was supposedly no well-being, no honor, no money. Line, color, composition, sincerity before nature, what have you. Why, only yesterday some mathematician was prescribing immutable lights and colors for us (Charles Henri discoveries).

The danger has passed. Yes, we are free, and yet, I see a peril looming on the horizon; I'd like to mention it to you. It's the main reason I've written this long, tedious letter. Today's critics —serious, full of good intentions, well-informed—tend to saddle us with a certain way of thinking, of dreaming, and that would be another form of slavery.

Preoccupied with what concerns them—their special field, literature—

Gauguin's house in Punaaiua, Tahiti.

they might lose sight of what concerns us, painting. If that were the case, I'd contemptuously quote Mallarmé's definition of a critic: a Gentleman who meddles in other people's affairs.

In memory of him, may I offer you these few hastily sketched lines, a dim recollection of a noble, beloved, clear-eyed face in the darkness—not a gift, but an appeal to the indulgence I need for my madness and my savagery.

Sincerely yours.

Face to Face with Gauguin

A few thumbnail sketches by Gauguin's contemporaries. A sampling of adjectives: gruff, self-confident, standoffish, derisive, charming, astounding, ridiculous, massive, passionate, generous, self-centered, handsome, cynical, legendary!

Osny, 1833

I am glad to know that Gauguin the terrible is with you. He would have been terribly distressed had he not been able to spend his vacation under your wing. For all his gruffness, he's a decent enough companion; you'll find him [working] in storms.

Guillaumin to Pissarro,
June 1883

Pont-Aven, 1886

Tall, dark-haired, and swarthy of skin, heavy of eyelid and with handsome features, all combined with a powerful figure, Gauguin at this time was a fine figure of a man....

He dressed like a Breton fisherman in a blue jersey, and wore a beret jauntily on the side of his head. His general appearance, walk and all, was rather that of a well-to-do Biscayan skipper of a coasting schooner; nothing could be farther from madness or decadence.... Most people were rather afraid of him, and the most reckless took no liberties with his person. "*C'est un malin*" ["He's a bad one"] was the sort of general verdict.

Archibald Standish Hartrick,
*A Painter's Pilgrimage
Through Fifty Years*, 1939

Paris, 1889–91

Gauguin returned to Paris late in 1889. He was forty-one at the time. He was a brawny, strapping man who, although of no more than average height, looked relatively tall because he was so well-proportioned. His livid complexion and strong but prematurely weathered

Portrait of Paul Gauguin. Woodcut by Daniel de Montfreid.

features betrayed periods of physical and mental suffering, which he kept a jealously guarded secret.

In those days there was nothing grand or imposing or conspicuous about the way he dressed....His headgear consisted of a dark blue beret; the long, buff-colored Macfarlane flung over his shoulders had turned permanently greenish. Underneath it could be glimpsed a jacket flecked here and there with paint. Instead of a vest the artist wore a navy blue jersey decorated with Breton appliqué work. His bell-bottomed trousers, which all but covered his carved wooden clogs, were too full. They were not the result of some clever design, but a ready-made garment purchased at the "*Incomparable*" ["Peerless"] store for the modest sum of 12 francs 50. In Gauguin's estimation the chief virtue of a piece of clothing was, as you'd expect, low cost. He had no source of income, so he had to watch every penny. For all that, he was an honest man and paid his tailor.

Jean de Rotonchamp,
Gauguin, 1906

Le Pouldu, 1889–90

Gauguin was forty-two at this time. He was in the prime of life, and his health was still intact. He stood upright and had a tanned face, long, dark hair, an aquiline nose, big green eyes, a sparse beard around his chin, and a short moustache.

He had a serious, imposing presence and a calm, deliberate demeanor that could turn sarcastic when philistines were around. He had great strength of body, which he was loath to use. His slow gait, measured movements, and stern expression endowed him with considerable natural dignity and kept strangers at bay. Behind this cold, impassive mask lay a passionate temperament constantly on the lookout for new sensations. As Gauguin never completed his formal education and was not versed in the classics, he viewed Greek and Latin [authors] with suspicion and incomprehension.

During his wanderings as a sailor he'd picked up some precepts of rudimentary pragmatism he summed up in a motto inscribed a number of times on the everyday objects he liked to decorate: "Long live wine, love, and tobacco!"

Thus, there was in Gauguin a great appetite for sensation but a total lack of sentiment. The basis of his character was a ferocious cynicism, the self-centeredness of the genius who considers the whole world fair game, a vehicle for the glorification of his power, a raw material for his personal creations....

But it was precisely that overblown, unchecked egoism of his that kept the artist from turning into a banal bourgeois or a barfly. He was, and remained, a heroic figure.

Mothéré,
quoted in Charles Chassé,
Gauguin et Son Temps, 1955

Tahiti, 1891

It should be stated right away that as soon as Gauguin landed he drew catcalls and looks of astonishment from the natives, especially the women. He had a tall, straight, powerful build and maintained an air of profound disdain despite his already awakened curiosity and, no doubt, anxiety about his future work....But the thing that especially held everybody's attention

was his long salt-and-pepper hair, which fell to his shoulders from beneath a broad-brimmed brown felt cowboy hat.

Lieutenant P. Jénot,
Gazette des Beaux-Arts,
Vol. XLVII, 1956

Paris 1893–5

Around this time Gauguin started wearing a strange outfit on the few occasions he would deign to call on someone.

It has remained legendary. It consisted of a long, blue, fitted frock coat with mother-of-pearl buttons. Underneath, a blue vest that buttoned down the side and had a green-and-yellow embroidered collar. Putty-colored trousers. On his head the painter sported a gray felt hat with a sky-blue hatband; his hands, more sturdy than shapely, were hidden under immaculately white gloves. Instead of a cane the artist carried a wooden walking stick decorated with his own barbaric carvings and inlaid with fine pearl.

To tell the truth, in this extravagant getup, Gauguin did not exude the stateliness of a Magyar or a Rembrandt; he looked more like a master of ceremonies at a musical revue. It was thus, in full regalia, that he was introduced in 1894 to the Under-secretary of State for the Colonies when he applied for—without success, incidentally—[government-sponsored] residency in the South Seas. Imagine the look of amazement on the ushers' faces when this astonishing applicant came through the doors!

Jean de Rotonchamp,
Gauguin, 1906

Le Pouldu, 1894

Gauguin was superb, straight as a sturdy tree, sneering like the angel that fell because of his pride.

Armand Séguin,
L'Occident, 1903

Atuona, 1902

Koke [Gauguin], the "picture-maker," lavished tobacco, rice, sweets, and material on the pretty girls he found so appealing and whose fragrant hair he so appreciated....The life [he] led in the Marquesas was not the primitive, secluded existence he seemed to wish for in his letters, but a very free existence. He was liberal toward the natives, let them take advantage of him as if for the fun of it, and never complained.

Guillaume Le Bronnec,
quoted in Pottier,
Gazette des Beaux-Arts, 1956

Atuona, 1903

In the last two years...a sick painter of the Impressionist school, Monsieur Gauguin, has settled at Atuona, in what he calls his "House of Pleasure." From the start he made it his business to set the natives against the authorities, inciting them to refuse payment of their taxes and stop sending their children to school. To the latter end, though an invalid who has difficulty in walking, he has even gone down to the shore in order to persuade people from Tahuata to return to their island with their children. This is corroborated by reports from the *gendarmerie*.

Report from Inspector A. Salles to the
Ministry of the Colonies,
August 1903,
quoted in Danielsson,
Gauguin in the South Seas

Back cover of *L'Esprit Moderne et le Catholicisme*, 1897–8.

Gauguin on Vincent van Gogh

Although Gauguin drafted his collected memoirs shortly before he died, they were not published until 1923 as Avant et Après *and 1951 as* Racontars de Rapin. *Here, nearly fifteen years after the fact, he recalls the tragic episode of his stay with Vincent van Gogh in Arles.*

I've been wanting to write about van Gogh for a long time, and one fine day I'll certainly do so, when I am in the mood. For the time being, I'm going to relate certain things about him—rather, about us—that should rectify a mistake that has been going around certain circles.

Surely it was by chance that in the course of my life several men who kept company with me and had discussions with me have gone mad.

This was the case with the van Gogh brothers; certain parties, out of malice—others, out of naiveté—have attributed their madness to me. Certainly some people can influence their friends to varying degrees, but that's a far cry from causing madness. Long after the catastrophe, Vincent wrote me from the mental asylum where he was being cared for. This is what he said:

"How fortunate you are to be in Paris! That is still where the leading authorities are, and you should certainly consult a specialist to cure you of madness. Aren't we all mad?" It was sound advice, that's why I didn't follow it, no doubt just to be contrary.

Readers of *Le Mercure* were able to see in a letter of Vincent's, published a few years back, how insistent he was about my coming to Arles to start up what he envisioned as a studio with myself at the helm.

I was working at the time at Pont-Aven, in Brittany. Whether because the studies I'd begun there created an affinity between me and the place, or because through some vague instinct I foresaw something abnormal, I held out

V incent van Gogh's *Self-Portrait Dedicated to Paul Gauguin*, 1888.

for a long time, until the day came when, won over by Vincent's heartfelt protestations of friendship, I started out.

I reached Arles late at night and waited for daybreak in an all-night café. The proprietor took one look at me and cried out, "It's you, his friend. I recognize you."

A self-portrait I had sent to Vincent will suffice to account for the owner's outburst. Vincent had shown him my portrait, explaining that it was a friend who would be arriving shortly.

Neither too early nor too late, I went to wake Vincent up. The day was given over to settling in, lots of chatter, and strolling about to admire the beauties of Arles and the Arlésiennes (for whom, by the way, I could not work up a great deal of enthusiasm).

We were at work the very next day—he picking up where he'd left off, I starting fresh. Now, I have never had the cerebral facility that others find so effortlessly at the tip of their brush. They step off the train, pick up their palette, and in no time flat you've got a sunlight effect. When it's dry it goes to the Luxembourg, and it's signed Carolus Duran.

I do not admire such painting, but I admire the man.

He's so confident, so calm.

I'm so undecided, so restless.

Whatever region I'm in, each and every time I've got to have an incubation period to learn the essence of the plants, the trees, all of nature—so varied and capricious, never willing to let herself be divined or revealed.

So, several weeks passed before I clearly grasped the sharp flavor of Arles and its environs. We worked steadily nonetheless, especially Vincent. Between the two of us, one a volcano,

the other seething, too, but within, a struggle was brewing.

First of all, I found everything in shocking disarray. His paint box was hardly big enough to hold all of those squeezed tubes, which were never resealed, and despite all that disorder, all that mess, everything on his canvas shone; so did his words. Daudet, de Goncourt, the Bible seared the brain of this Dutchman. In Arles the quays, bridges, boats, the whole south of France became another Holland for him. He even forgot to write in Dutch and, as can be seen from his published letters to his brother, he never wrote in anything but French and did so admirably, with no end of [phrases like] *tant que* and *quant à*.

Despite all my efforts to disentangle from that scrambled mind of his a rationale underlying his critical views, I couldn't account for the contradiction between his painting and his opinions. For example, he had boundless admiration for Meissonier and a profound loathing for Ingres. Degas was his despair, and Cézanne was nothing but a humbug. The thought of Monticelli brought tears to his eyes.

One of the things that raised his hackles was to be forced to admit that I had great intelligence even though my forehead was too small, a sign of imbecility. And with all that, deep tenderness, or rather, the altruism of the Gospel.

From the very first month I saw our joint finances showing the same symptoms of disorder. How was I to handle this? It was a ticklish situation, as the cash box was being filled, albeit modestly, by his brother, who worked for Goupil's and, for my part, by arranging exchanges of paintings.

Something had to be said, and there was no escaping a showdown with that hair-trigger sensitivity of his. I broached the subject, but only with considerable precaution and wheedling that were hardly in keeping with my personality. I must confess, I succeeded far more easily than I expected.

In one box there would be so much for hygienic nighttime strolls [prostitutes], so much for tobacco, so much for unforeseen expenses, including rent. Atop all that a piece of paper and a pencil to jot down honestly what each of us took from the till. In another box, whatever was left over, divided in four, for each week's food allowance. We stopped going to our little restaurant, and with the help of a little gas stove I did the cooking and Vincent did the food shopping, staying fairly close to the house. Once, however, Vincent tried to make some soup, but how he mixed his ingredients I cannot say—probably the way he did his colors on his canvases. At any rate, it wasn't fit for consumption. And my Vincent exclaimed, laughing, "*Tarascon! la casquette au père Daudet!*" On the wall he wrote in chalk:

Je suis Saint-Esprit. [I am the Holy Spirit.]

Je suis sain d'esprit. [I am sound of mind.]

How long did we stay together? I couldn't say, having completely forgotten. Although the catastrophe quickly bore down on us and I was working at a fever pitch, that entire period seemed like a century to me.

The public never suspected that two men did tremendous work there, useful to them both. Perhaps to others, too. Certain things bear fruit.

When I arrived at Arles, Vincent was involved with the Neo-Impressionist school. And he was floundering considerably, which distressed him. Not because this school, like all schools, was bad—by no means—but because it did not suit that impatient, independent temperament of his.

With all those yellows on violets, all that work in complementary colors— disordered work on his part—he ended up with nothing but subdued, incomplete, monotonous harmonies; the sound of the clarion was missing.

I set about trying to enlighten him, which was easy, for I found in him a rich and fertile ground. Like all people who are original and marked with the stamp of individuality, Vincent had no fear of those around him and no stubbornness.

From that day forward, my van Gogh made astonishing progress. He seemed to glimpse all that was within him, and that led to the whole series of suns on suns in full sunlight.

"Have you seen the portrait of the poet?

1. Face and hair, chrome yellow;

2. Clothing, chrome yellow;

3. Tie, chrome yellow, with an emerald, green-emerald pin against a

4. Chrome yellow background."

That is what an Italian painter said to me, and he added: "Shit, shit, everything's yellow. I don't know what painting is anymore!"

There's no need to go into details of technique here. I mention this so you'll know that van Gogh, without losing a single ounce of his originality, profited from what I had to teach him. And every day he'd thank me for it. And that's what he meant when he wrote to Monsieur Aurier that he owed a great deal to Paul Gauguin.

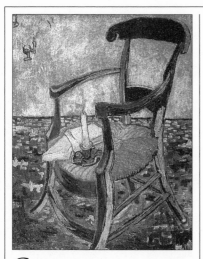

Gauguin's Chair, by van Gogh, 1888–9.

When I arrived in Arles, Vincent was still trying to find his way, whereas I, who was much older, was a mature man. I do owe Vincent something, however, and that is the knowledge of having been of use to him, and the confirmation of my earlier ideas about painting; then, too, when the going gets tough, remembering that there's always someone unhappier than oneself....

Toward the end of my stay Vincent became excessively curt and noisy, then tight-lipped. Some nights I caught Vincent, who had gotten up, coming toward my bed.

What caused me to wake up just at that moment?

At any rate, all I had to do was say to him very solemnly, "What's the matter, Vincent?" and without a word he'd slip back into bed and fall into a deep sleep.

I hit upon the idea of painting his portrait while he was at work on the still life he loved so, the one with sunflowers. When I finished the portrait he said, "That's me all right, but me gone mad."

That very evening we went to the café. He ordered a light absinthe.

Suddenly he threw his glass and its contents at my head. I ducked, and, grabbing him bodily in my arms, left the café and crossed Place Victor Hugo. A few minutes later, Vincent found himself in bed and in a few seconds fell asleep. He didn't awaken again until morning.

When he did wake up, he said to me very calmly, "My dear Gauguin, I vaguely remember having offended you last night."

Reply: "I gladly forgive you with all my heart, but there could be a replay of yesterday's scene, and if I were struck I might lose control of myself and throttle you. If I may, I'd like to write to your brother and inform him that I'm coming back."

My God, what a day!

That evening, after a half-hearted attempt at dinner, I felt the need to go out alone and get some fresh air, scented with flowering laurel. I had almost finished crossing Place Victor Hugo when I heard a familiar stride— short, quick, jerky—behind me. Just as I turned around, Vincent rushed toward me, an open razor in his hand. I must have had a daunting look on my face at the time, because he stopped short and, lowering his head, scurried back toward the house.

Was I lax just then? Shouldn't I have disarmed him and tried to calm him down? I've often examined my conscience, and I find nothing to reproach myself for.

Let those who will cast stones.

I darted over to a good hotel in Arles where, after asking what time it was, I booked a room and went to bed.

I was very restless and didn't drop off to sleep until about 3 in the morning. I woke up fairly late, about 7:30.

I went out into the square, where a large crowd had gathered. Near our house, [there were] some policemen and a short gentleman in a bowler hat who was the police commissioner.

This is what had happened.

Van Gogh went back home and immediately cut off his ear close to the head. It must have taken him some time to stanch the hemorrhage, because the following day the floor tiles of the two rooms downstairs were littered with wet towels. There were bloodstains in the two rooms and on the little staircase leading up to our bedroom.

When he felt up to going out, he covered his head with a Basque beret pulled all the way down and went straight to a certain house where if you didn't know any local women a chance acquaintance could be procured, and gave the "sentry" his ear, which he had thoroughly washed and enclosed in an envelope. "Take this," he said, "in remembrance of me." Then he bolted and headed home, where he went to bed and fell asleep. However, he took the trouble to close the shutters and set a lighted lamp on a table near the window.

Ten minutes later the street set aside for the *filles de joie* was in commotion and all abuzz.

I did not have the slightest inkling of all this when I appeared at the threshold of our house and the gentleman in the bowler hat said to me point-blank in a very severe tone of voice, "What have you done to your friend, sir?" "Why,

what do you mean?" "You know perfectly well what I mean. He's dead."

I would not wish a moment like that on anyone, and it took me a good few minutes to regain my composure and keep my heart from racing.

I was suffocating with anger, indignation, grief as well, and the shame of all those stares tearing me to shreds. "Very well, sir," I stammered. "Let's go upstairs and we'll sort things out up there." Vincent was lying in bed, all curled up and completely enveloped in sheets. He appeared lifeless. Gently, ever so gently, I touched his body; its warmth told me that he had to be alive. It was as if all my presence of mind, all my energy, had suddenly come back to me.

Almost in a whisper I said to the police commissioner, "Sir, would you be so kind as to wake this man up with great care, and if he asks for me tell him that I've gone to Paris. The sight of me could be fatal to him."

I must confess that from that moment on, the police commissioner was as reasonable as he could be, and he wisely sent for a doctor and a carriage.

Once he was awake, Vincent asked for his comrade, his pipe and tobacco, and even thought of asking for the cash box we kept downstairs. A suspicion, no doubt, but one that only grazed me, armed as I already was against all suffering.

Vincent was taken to the hospital. As soon as he got there, his mind started to wander again.

Anyone interested in this knows all the rest. There's no need to discuss it further, except to mention the extreme suffering of a man who was cared for in an insane asylum, yet who regained enough of his reason at

monthly intervals to understand his condition and furiously paint the wonderful pictures people are now so familiar with.

The last letter I got from him was dated Auvers, near Pontoise. He told me that he had hoped to recover enough to visit me in Brittany, but that now he had to admit that a cure was impossible.

"Dear Master (the only time he ever uttered that word), after having known you and caused you distress, it is more dignified to die in a sound state of mind than a deteriorated one."

And he shot himself in the stomach with a pistol. It was not until a few hours later, lying in bed and puffing on his pipe, that he died, with complete lucidity of mind, with love for his art and without any hatred for others.

In *Les Monstres*, Jean Dolent writes, "When Gauguin says 'Vincent,' his voice is gentle."

Without knowing it, but having guessed it, Jean Dolent is right. We know why.

Avant et Après,
written 1902, published 1923

T he Alyscamps, Arles, as seen in a nineteenth-century photograph.

Symbolism in Painting

A "Manifesto of Symbolism" for literature was published in 1886. Five years later a young poet and critic, Albert Aurier, wrote a counterpart for painting aimed at describing and celebrating the art of Symbolism's leading exponent, Paul Gauguin.

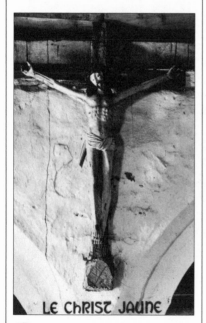

LE ChRIST JAUNE

Crucifix in the Trémalo Chapel, Finistère.

Far, far away, on a fabulous hill, where the ground seems to glow bright red, Jacob's Biblical struggle with the Angel is taking place....

Now, as I look at this wonderful painting by Paul Gauguin, which truly illuminates the enigma of the Poem, during primitive humanity's paradisiacal days; which reveals the ineffable charms of Dream, Mystery, and the symbolic veils only half-lifted by the hands of the simple-hearted; which, for the perceptive reader, resolves the eternal psychological problem of the feasibility of religion, politics, and sociologies; and which shows the fierce primordial beast tamed by Chimera's spellbinding philters—as I look at this miraculous painting, not some fat, pompous banker glorying in a gallery cluttered with Detailles (a sure bet) and Loustauneaus (an investment), but a certain art lover, known to be intelligent and friendly toward youthful audacities to the point of accepting the Pointillists' harlequinesque vision, was heard to exclaim:

"Really now!…This one is the limit!…Ploërmel's headdresses and shawls, Breton women, and from this late nineteenth century of ours, in a picture entitled *Jacob Wrestling with the Angel*!! Now, I'm certainly no reactionary. I accept Impressionism; in fact, I accept nothing but Impressionism, but…."

"And who told you, my dear sir, that this was an Impressionist painting?"

Perhaps the time has come to clear up a troublesome misunderstanding, undoubtedly created by the word Impressionism, which has been misused.

The public [labels] Impressionist

painters all those who, having rebelled against the moronic tastes of the boulevard critics and benighted academic formulators, allow themselves the presumptuous freedom of not copying someone else.

That would be all right, and that term would be as good as any other, except that, unfortunately, however broadly the term is used, it implies a meaning—indeed, a precise meaning—that may well be misleading the public. Like it or not, the word "Impressionism" suggests a whole aesthetic agenda based on sensation. Impressionism is and can only be a variety of Realism, a honed, spiritualized, amateurized Realism, but Realism just the same. It still aims at the imitation of material existence, no longer, perhaps, in its intrinsic form and color, but in its perceived form and color. It is a translation of sensation, with all the unexpected qualities resulting from instantaneous notation, with all the distortions resulting from rapid, subjective synthesis. To be sure, Messrs. Pissarro and Claude Monet render forms and colors differently than Courbet; but basically, like Courbet—even more so than Courbet—they render nothing but form and color. The underlying, ultimate goal of their art is material subjects, real things. Therefore, as they utter this word "Impressionism," the public inevitably has the vague notion of a special kind of Realism; they expect works that are simply a faithful rendering of an *exclusively sensory impression* of a sensation—*and nothing more.…*

Oh, how truly rare among those who pride themselves on their "artistic bent," how rare are those fortunate beings whose eyelids of the soul are half-open and who can exclaim with Swedenborg, that inspired hallucinator: "That very night, the eyes of my inner self were opened. They were able to gaze into the heavens, into the world of ideas and into the nether realm!…" And yet, isn't that the inescapable, prerequisite initiation a true artist, an absolute artist, must undergo?…

Paul Gauguin seems to me to be one of those sublime gazers. To me, he is the initiator of a new art, not in history, but at least in our time. Therefore, let us analyze this art from the standpoint of a general aesthetic. That would, I feel, be tantamount to studying the artist himself, and might be an improvement on what critics nowadays are usually satisfied with, namely, a superficial monograph consisting of descriptions of twenty or so paintings and ten flattering clichés.…

As I have said, the natural and ultimate goal of painting—indeed, of all the arts—cannot be the direct representation of objects. Its end is to express ideas by translating them into a special language.

In the artist's eyes (that is, in the eyes of anyone who is supposed to be an *Evocator of Absolute Entities*), objects—the relative entities that are only a translation of absolute, essential entities (Ideas), adjusted to the relativity of our intellects—objects can have no value *qua* objects. They can only appear to him as *signs.* They are letters in an immense alphabet that only a man of genius knows how to spell out.

To write his thoughts, his poem, with these signs (bearing in mind that, indispensable though signs may be, they are nothing in themselves and that ideas alone are everything)—that, therefore, appears to be the task of the artist

whose eyes have learned how to discern the essence of tangible objects. The first consequence of this principle—too obvious to dwell upon here—is, as one might guess, a necessary *simplification in the writing of signs.* If this were not so, wouldn't the painter be akin to the writer who fancies he is adding something to his work by polishing his penmanship and ornamenting it with useless flourishes?...

Therefore, to sum up and conclude: a work of art, as I have chosen logically to define it, will be:

1) *Idea-ist*, since its sole ideal will be to express Ideas;

2) *Symbolist*, since it will express those Ideas through forms;

3) *Synthetic*, since it will present those forms, those symbols, in a generally intelligible manner;

4) *Subjective*, since an object in a work of art will never be looked upon as an object, but as the sign of an idea perceived by the subject; and, consequently,

5) *Decorative*—for decorative painting per se, as the Egyptians and quite probably the Greeks and Primitives understood it, is none other than a manifestation of art that is at once subjective, synthetic, symbolist, and idea-ist.

Now, if we think it over carefully, decorative painting is, strictly speaking, true painting. Painting could only have been invented to *decorate* the banal walls of human edifices with thoughts, dreams, and ideas. Easel painting is nothing but an illogical refinement, devised to satisfy the whim or commercial spirit of decadent civilizations. In primitive societies, the earliest attempts at painting could not have been anything but decorative.

Thus, the art which we have attempted to legitimate and characterize by all the preceding deductions, the art which may have seemed complicated and which some columnists so readily call decadent art, ends up, in the final analysis, reduced to a type of simple, spontaneous, primordial art. That is the criterion on which the soundness of my aesthetic arguments has been based. Therefore, Idea-ist art—which had to be justified by abstract, involved reasoning because it seems so paradoxical to these decadent civilizations of ours that have forgotten all the initial revelations— Idea-ist art is, indisputably, genuine, absolute art, since it is not only legitimate from a theoretical standpoint, but also fundamentally identical to primitive art, to art as it was divined by the instinctive geniuses of humanity's earliest days....

Such is the art I take comfort in dreaming of, such is the art I like to imagine during the compulsory strolls I take amidst the miserable or degenerate "artwork" that clutters our industrial exhibitions. Such, too, I feel—unless I have misinterpreted the thinking behind his work—is the art which Paul Gauguin, that great artist of genius, has tried to establish in this deplorable, rotten nation of ours.

I cannot describe or analyze his already marvelous work here. It is enough for me to have attempted to characterize and legitimate the highly laudable aesthetic that seems to guide this great artist. How can words do justice to that whole inexpressible ocean of Ideas that a perspicacious eye can glimpse in his masterful paintings: in *Calvary, Jacob Wrestling with the Angel,* or *The Yellow Christ*; in those wonderful

*S*oyez Amoureuses, Vous Serez Heureuses
(*Be in Love and You Will Be Happy*), 1890.

landscapes of Martinique and Brittany, where every line, every form, every color is the word for an Idea; in that sublime *Agony in the Garden*, where, in a desolate setting, a seated, incarnadine-haired Christ, seems to mourn the ineffable sorrows of dreams, the agony of Chimeras, the treason of contingency, the vanity of reality, of life, and, perhaps, of the hereafter?...

How can I convey the philosophy carved into the bas-relief that ironically reads *Be in Love and You Will Be Happy*, in which all the lust, the whole conflict between mind and flesh, all the sorrow of sexual delight writhe and, so to speak, gnash their teeth? How can I describe that other wood sculpture, *Be Mysterious*, which celebrates the pure joys of esotericism, the disturbing caresses of the riddle, the fantastic shadows of enigma's forests? Lastly, what is there to say about those strange, barbaric, savage ceramics into which this sublime potter has worked more soul than clay?...

Yet, if we think it over, as disturbing, masterly, and wonderful as this work may be, it is but little compared with what Gauguin might have turned out had he lived in another civilization. It bears repeating: Gauguin, like all Idea-ist painters, is above all a decorator. His compositions are too cramped by the limited field of canvases. At times, one would be tempted to take them for fragments of huge frescoes, and they almost always seem ready to burst the frames that unduly confine them!...

In short, we have, in this dying century of ours, but one great decorator—two, perhaps, counting Puvis de Chavannes—and our moronic society of bankers and Ecole Polytechnique graduates refuses to give this rare artist the least palace, the least little national hovel where the mantle of his dreams might hang!

The walls of our Pantheons of Stupidity are sullied by the ejaculations of painters like Lenepveu and the nonentities from the Institute!...

Oh, gentlemen, how posterity will curse you, mock you, spit on you if one day a feeling for art is rekindled in humanity's spirit!...Come now, a little common sense! You have among you a decorator of genius. Walls! Walls! Give him walls!...

Albert Aurier,
"Le Symbolisme en Peinture,"
Mercure de France
9 February 1891

Noa Noa

These excerpts are from Noa Noa ("Fragrant"), *an original manuscript Paul Gauguin drafted in Paris in 1894 from notes he had made in Tahiti. The purpose of the book was to educate the public about Tahitian mythology and daily life and help them understand the seemingly mysterious pictures he had painted in the South Seas. The following selection is the most autobiographical section of his account.*

PAUL GAUGUIN

NOA NOA

ÉDITION DÉFINITIVE

BOIS DESSINÉS ET GRAVÉS
D'APRÈS PAUL GAUGUIN
PAR DANIEL DE MONFREID

To one side, the sea. To the other, a mango tree against the mountain, covering the entrance to a fearsome cave.

Near my hut was another hut (*fare amu*, house to eat in). Nearby, a canoe. While the sickly coconut palm looked like a huge parrot, its golden tail drooping and a huge cluster of coconuts clutched in its claws.

A nearly naked man was raising with both hands a heavy ax that left, at the top of its stroke, a blue imprint on the silvery sky; as it came down, [it left] its incision on a lifeless tree which would soon live again as an instant of flames, age-old heat stored up day by day. On the purple ground, long, serpentine, copper-colored leaves, a whole Oriental vocabulary, letters (it seemed to me) of an únknown, mysterious language. I seemed to make out that word of Oceanic origin, *Atua*, "God."... A woman was stowing some nets in her canoe, and the horizon of the blue sea was often broken by the green crests of waves against the coral reefs....

That evening I went to smoke a cigarette on the sand, by the sea. The sun was rapidly sinking toward the horizon and starting to hide behind the isle of Moorea, which lay to my right. Through a contrast of light, the mountains were etched darkly, powerfully, against the blazing sky. All those peaks [looked] like old crenelated castles....

Night fell quickly. This time, Moorea was still asleep. I fell asleep, later, in my bed. Silence of a Tahitian night. All I could hear was the beating of my heart. The moonlight filtered in, and from my bed I could make out the rows of uniformly spaced reeds of my hut—like a musical instrument. The *pipo* of the

ancients—what the Tahitians call the *vivo*—only silent—it speaks at night through memories. I fell asleep to that music. Overhead, the tall, spreading roof of screw-pine leaves, where the lizards dwell. In my sleep I could see the space above my head, the vault of the heavens. No stifling prison, this: my hut was space, freedom....

I wandered off the coast road and went through a thicket that led me fairly deep into the mountains. Came to a little valley where the inhabitants still try to live the way their ancestors did. The pictures *Matamua* (*Yesteryear*) and *Hina Maruru*....

I set off again. Reached Taravao (far end of the island). A policeman loaned me his horse. I rode along the east coast, which Europeans seldom visit. Came to Faaone, a little district that precedes the district of Itia. A native called out to me:

"Hey there! Man-Who-Makes-Men!" (He knows I am a painter.) "Come eat with us!" (*Haere mai ta maha,* the phrase used when offering hospitality.)

I didn't have to be asked twice, his face was so gentle. I got down off my horse. He tied it to a branch, simply, skillfully, without a hint of servility.

I entered a hut where several men, women, and children were sitting together on the ground, chatting and smoking.

"Where are you going?" asked a beautiful Polynesian woman of about forty.

"To Itia."

"What for?"

I don't know what I was thinking of when I replied, "To look for a wife. There are lots of pretty ones in Itia."

"Do you want one?"

"Yes."

"I'll give one to you, if you like. She's my daughter."

"Is she young?"

"*Eha* [Yes]."

"Is she pretty?"

"*Eha.*"

"Is she in good health?"

"*Eha.*"

"Very well, then. Go and bring her to me."

She went out. A quarter of an hour later, as they were bringing in a Polynesian meal of wild bananas and prawns, the older woman came back, followed by a full-grown girl with a little bundle in her hand.

I could see the golden skin of her shoulders and arms through her extremely sheer pink muslin dress: Two buds swelled on her breasts. Her charming face looked different from the others I had hitherto seen elsewhere on the island. Her hair was thick as a brush, a little frizzy. In the sunlight, an orgy of chrome [yellows]. I found out that she came from Tonga.

She sat down beside me, and I asked her some questions.

"Aren't you afraid of me?"

"*Aita* [No]."

"Would you like to dwell in my hut for all time?"

"*Eha.*"

"Have you ever been ill?"

"*Aita.*"

That was all. My heart was thumping as she impassively laid out the food before me on a big banana leaf on the ground. Although I had a hearty appetite, I ate diffidently. This girl of about thirteen captivated me and struck terror in me. What was going through her heart? I hesitated to put my name on this contract, for I was so old compared to her.

Perhaps she was acting on her mother's orders, as part of a prearranged deal. And yet, I sensed in this overgrown child the independence and pride of her entire people, the serene bearing of a laudable deed. Her soft, yet mocking lips suggested that I was the one in danger, not she. I cannot say [that] I left the house without fear. I untied my horse and mounted.

The girl followed behind. Her mother, a man, and two young women—her aunts, she said—followed, too. We returned to Taravao, nine kilometers from Faaone.

After the first kilometer, they said, "*Parahi teie* [Stop here]."

I dismounted and went into a large, neatly kept, almost opulent hut. The opulence of riches from the earth, with pretty mats on the ground, over straw....A fairly young and exceptionally gracious couple lived there, and the young girl sat next to her mother and introduced her to me. Silence. Cool water was passed around, and we drank in turn as though it were a religious offering. The young mother said to me, tears of emotion welling up in her eyes:

"Are you kind?"

I examined my conscience.

"Yes," I replied, not without some difficulty.

"Will you make my daughter happy?"

"Yes."

"She must come back in eight days. If she is not happy, she'll leave you."

A long silence. We went out and I started out again on horseback. They followed behind. We met several people along the way.

"Well, well! So now you are the *vahiné* of a Frenchman? Be happy!"

"Good luck."...

The family took their leave of us at Taravao, at a Chinaman's where everything—man, beast, what have you—was for sale. My bride and I took the public coach that brought us to Mataiea, twenty-five kilometers away.

My new wife was not very talkative; melancholy and mocking. The two of us kept studying each other. She was impenetrable; I was quickly beaten in that contest. In spite of all my inner resolve, my nerves soon got the better of me and, in a very short time I was, for her, an open book....

A week went by during which I had a "childlike" feeling I had never had

Manao Tupapau (*Spirit of the Dead Watching*), from *Noa Noa*, 1893–4.

before. I loved her and told her so; that made her smile (she knew it, all right!). She seemed to love me, too, but never told me so. Sometimes, at night, flashes of lightning streaked the gold of Tehamana's skin. That was all. That was so much.

On the eighth day—the week sped by so fast it seemed like a day, an hour—she asked me if she could visit her mother at Faaone. She had promised to do so.

She left, and, sad at heart, I put her in the public coach with a few piastres tied in her handkerchief to pay the fare and buy some beer for her father. I felt

as though we'd never see each other again. Would she come back?

A few days later, she did.

I started working again, and happiness came on happiness.

Every day, at the first glimmer of sunrise, the light inside my room was radiant. The gold of Tehamana's face flooded everything around it, and the two of us would go, in all naturalness and simplicity, as in the Garden of Eden, to seek refreshment in a nearby brook.

Everyday life. Tehamana became more and more docile and loving. Her Tahitian *noa noa* (fragrance) permeated everything. I no longer knew what day or time it was; I was no longer aware of Good and Evil. All was beautiful; all was well. Instinctively, Tehamana fell silent whenever I was working, whenever I was dreaming. She always knew when to speak without disturbing me.

We talked about Europe, about God, and the gods. She learned from me and I from her.

Everyday life. Nighttime conversations in bed. She was very much interested in the stars. She asked me the French name for the morning star, the evening star. She found it hard to understand that the Earth revolves around the sun. She, in turn, told me the names of the stars in her language....

What she would never admit is that those shooting stars, commonly seen in these parts crossing the sky in a slow, melancholy fashion, might be *tupapaus* [spirits of the dead].

Strindberg and Gauguin

Gauguin asked the Swedish playwright, a regular at the soirées in the Rue Vercingétorix studio, to write a preface for the catalogue of his upcoming sale at the Hôtel Drouot on 18 February 1895, just before the artist's final departure for the South Seas. Strindberg declined. Instead of the usual preface, Gauguin printed Strindberg's letter of refusal and his own reply.

August Strindberg, c. 1894.

AUGUST STRINDBERG
TO PAUL GAUGUIN,
1 FEBRUARY 1895

You insist upon my writing the preface to your catalogue as a remembrance of the winter of 1894-5, when we lived here behind the Institute, not far from the Panthéon, and right next to the Montparnasse cemetery.

I would willingly have given you this remembrance to take to that Oceanian island where you are going to look for some space and for a setting harmonious with your powerful stature, but I feel that I have been in an equivocal situation from the beginning, and I'm immediately responding to your request with an "I cannot" or, more brutally, with an "I don't want to."

At the same time, I owe you an explanation for my refusal, which does not come from a lack of kindness or from a lazy pen, although it would have been easy for me to have placed the blame on the already famous disease of my hands, which, in any event, has not caused my hands to fall into disuse from inactivity.

Here's why: I cannot grasp your art, and I cannot like it. (I cannot get a grip on your art, which is now so exclusively Tahitian.)

But I know that this confession will neither surprise you nor hurt you, because you rather seem to be strengthened by other people's hatred; anxious to remain intact, your personality delights in the antipathy it provokes. And rightly so, perhaps, because, from the moment you were appreciated and admired and had followers, you would be grouped and

classified, and your art would be given a name which young people would use, not even five years from now, as an epithet to designate an outdated art which they would do anything to make even more obsolete.

As for me, I made serious efforts to categorize you, to see you as a link in the chain, and to bring myself to an understanding of the story of your development—but in vain....

Last night my thoughts turned toward Puvis de Chavannes, to the southern sounds of the mandolin and guitar: I envisioned the confusion of sun-filled paintings on the walls of your studio, an image which pursued me into my sleep. I saw trees no botanist would ever find, animals Cuvier never thought existed, and men only you could create.

A sea that would flow from a volcano, a sky in which no God can live. "Sir," I said in my dream, "you have created a new earth and a new sky but I don't like being in the midst of your creation. It is too sunny for me, a lover of chiaroscuro. And an Eve lives in your paradise who is not my ideal, for I, too, have a feminine ideal or two!"

This morning, I went to visit the Luxembourg museum in order to glance at Chavannes' works, which kept coming back into my mind. With a deep appreciation, I contemplated *Poor Fisherman*, so attentively awaiting the prey that will bring him the faithful love of both the wife who gathers flowers and his idle child. How beautiful it is!

But then my eye is struck with the fisherman's crown of thorns. I hate Christ and crowns of thorns. Monsieur, I hate them, hear me well. I want nothing to do with this pitiful God who accepts being hurt. Rather, my God is Vitsliputsli, who eats the hearts of men under the sun.

No, Gauguin was not created from Chavannes' rib, nor from Manet's, nor Bastien-Lepage's.

What is he, then? He is Gauguin, the savage who hates the restraints of civilization, who has something of the Titan who, jealous of the Creator, makes his own little creation in his spare time, the child who takes his toys apart to make others; the one who renounces and defies, preferring to see the sky red, rather than blue with the crowd.

Upon my word, it seems to me that, now that I've gotten excited writing, I'm starting to have a certain understanding of Gauguin's art.

A modern author has been reproached for not having painted real beings but for having constructed *quite simply* his own characters. *Quite simply*!

Have a good trip, Master; but do not come back and find me. Perhaps then I will have learned to understand your Art better, which will allow me to write a sincere preface for a new catalogue in a new Hôtel Drouot, because I, too, am starting to feel an immense need to become a savage and to create a new world.

PAUL GAUGUIN
TO AUGUST STRINDBERG,
C. 16 FEBRUARY 1895

I got your letter today, your letter which is a preface for my catalogue. I had the idea of asking you to do this preface when I saw you playing the guitar and singing the other day in my studio; your blue Nordic eyes were

looking attentively at the paintings hung on the walls. I felt the premonition of a revolt: a great shock between your civilization and my barbarity.

Civilization from which you suffer. Barbarity which is, for me, a rejuvenation.

In front of the Eve of my choosing, whom I painted with forms and harmonies from another world, your precious remembrances perhaps evoked a painful past. The Eve of your civilized conception makes you and makes us almost misogynous; the ancient Eve in my studio who scares you may very well smile less bitterly at you some day. This world, which perhaps neither Cuvier nor a botanist would be able to recognize, could be a Paradise only I could have sketched. While there is a great distance from the sketch to the realization of the dream, it doesn't matter!

To envision happiness, isn't this a foretaste of *nirvana*?

The Eve I painted (she alone) can, logically, go naked before our eyes. Yours, in this simple attire, could not walk without shamelessness and, too beautiful (perhaps) would be the evocation of evil and pain.

In order to make you fully under-stand my thoughts, rather than compare these two women directly, I will compare the Maori or Turanian language my Eve speaks with the language spoken by your woman and chosen among all others, the inflected European language.

With basic components of the language conserved in their state of crudeness—isolated or linked without any care for polish—everything is naked, striking, and primordial in the language of Oceania.

In inflected languages, on the other hand, the roots by which they started, as with all other languages, disappear in the daily commerce that has worn away their relief and contours. It is a perfected mosaic in which the joints between the stones (more or less crudely aligned) are no longer seen, and one admires only a beautiful lapidary painting. Only a skilled eye can survey the process of construction.

Forgive me for this long digression on language; I find it necessary to explain the savage drawing I had to use in order to decorate a Turanian country and its people.

All that remains, dear Strindberg, is for me to thank you.

When will we see one another again?

Until then, as today, I am yours truly.

Poster announcing the public auction of works by Paul Gauguin, Paris, 18 February 1895 (above left). *Eve*, woodcut printed in black on japan paper (above right).

Interview with Paul Gauguin

The following conversation with Paul Gauguin, published in the widely circulated L'Echo de Paris *on 15 March 1895, took place shortly before his final departure for the South Seas. Although somewhat "tidied up" by journalist Eugène Tardieu, the tone of Gauguin's writings comes through fairly well.*

Self-portrait in a letter to Emile Schuffenecker, 9 October 1888.

He is the wildest of all the innovators, and of all the "misunderstood" artists the one least inclined to compromise. A number of his discoverers have forsaken him. To the great majority of people he is just a humbug. Yet he calmly goes on painting his orange rivers and red dogs, and for every day which passes adheres more and more to his personal manner.

Gauguin is built like a Hercules: His graying hair is curly, his features are energetic, his eyes clear; and when he smiles in his characteristic way he seems alike gentle, shy, and ironical.

"What exactly does it mean, this expression 'to copy nature'?" he asks me, stretching himself defiantly. "'Follow the example of the masters,' we are advised. But what for? Why should we follow their example? They are masters for the sole reason that they refused to follow anybody else's example. Bouguereau has talked of women glowing in all the colors of the rainbow and denies the existence of blue shadows. One can just as well deny the existence of brown shadows such as he paints; what cannot be denied is that his canvases are devoid of any glow.... After all, it matters little whether blue shadows do or do not exist. If a painter tomorrow decides that shadows are pink, or violet, there is no reason why he should have to defend his decision, assuming that his work is harmonious and thought-provoking."

"Then, your red dogs and pink skies?"

"Are deliberate. Absolutely deliberate. They are necessary. Every feature in my paintings is carefully considered and calculated in advance. Just as in a musical composition, if you like. My simple object, which I take from daily life or from nature, is merely a pretext,

which helps me by means of a definite arrangement of lines and colors to create symphonies and harmonies. They have no counterparts at all in reality, in the vulgar sense of that word; they do not give direct expression to any idea, their only purpose being to stimulate the imagination—just as music does without the aid of ideas or pictures—simply by that mysterious affinity which exists between certain arrangements of colors and lines and our minds."

"These are rather novel theories!"

"They are not at all novel! All great artists have always done exactly the same. Raphael, Rembrandt, Velázquez, Botticelli, Cranach, they all distorted nature. Go to the Louvre and look at their pictures and you will see how different they are. According to your theory, one of them must be right and the rest wrong. Unless they have all been deceiving us. If you demand that a work should be true to nature, then neither Rembrandt nor Raphael succeeded, any more than Botticelli or Bouguereau. Shall I tell you what will soon be the most faithful work of art? A photograph, when it can render colors, as it will soon be able to...."

"So you do not wish to be called revolutionary?"

"I find the expression ridiculous. Monsieur Roujon has applied it to me. I told him that all artists whose work differs from their predecessors' work have merited it. Indeed, it is for that reason alone that they are masters. Manet is a master, and Delacroix. At first their work was considered atrocious, and people laughed at Delacroix' violet horses—which, incidentally, I have looked for in vain in his pictures. But such is the public. I have become reconciled to the idea that I shall remain misunderstood for a long time to come. If I only did what others have already done before me I should in my own estimation be just a worthless plagiarist. But whenever I strive to conceive something new I am called wretched. In that case, I would rather be called a wretch than a plagiarist."

"There are many cultivated people who think that, as the Greeks achieved sculpture of ideal perfection and purity and the Renaissance did the same in painting, nothing now remains but to emulate their works. The same people would even say that the plastic arts have exhausted their potentialities!"

"That is an absolute mistake. Beauty is eternal and can have a thousand forms. The Middle Ages had one ideal of beauty, Egypt another. The Greeks strove for complete harmony of the human body, and Raphael had very beautiful models. But you can equally well produce a valid work of art from a model that is as ugly as sin. There are plenty of such works in the Louvre."

"Why did you make your journey to Tahiti?"

"I had once been fascinated by this idyllic island and its primitive and simple people. That is why I returned and why I am going back there again. In order to achieve something new, you have to go back to the sources, to childhood. My Eve is almost animal. That is why she is chaste for all her nakedness. But all the Venuses in the Salon are indecent and disgracefully lewd. Before leaving, I shall publish in collaboration with Charles Morice a book about my life in Tahiti...."

"What will be its title?"

"*Noa Noa*—a Tahitian word meaning 'fragrant.' In other words, the book will be about what Tahiti exhales."

Backdrop for the Final Act

Victor Segalen (1878–1919), future author of Les Immémoriaux, Stèles, *and* René Leys, *was a young Navy physician of twenty-five when, in 1904, shortly after Gauguin's death, he traveled to Atuona and wrote this description of his studio. His eyewitness account of Gauguin's life in the Marquesas Islands was the first to be published in Paris.*

It was a sumptuous pall of a backdrop, befitting his death agony, splendid, yet sad, a bit paradoxical. Telling, illuminating, it set just the right mood for the final act of that roving life. But the reflected glow of Gauguin's forceful personality in turn illuminates these surroundings, the place he chose to be his last home, bringing it to life, filling it to overflowing; so much so that the leading man himself, his native "supers," and the sets and props around him can all be rigorously examined as facets of one and the same vision.

Gauguin was a monster. That is, he could not be pigeonholed into any of the moral, intellectual, or social categories that suffice to describe most individuals. For the common herd, to judge is to label. You can be a reputable tradesman, an upstanding official, a gifted painter, a poor but honest fellow, a well-bred young woman; you can be an "artist," even a "great artist." But even that is less permissible, and to be

T̶wo wooden panels from the door of Gauguin's "House of Pleasure" in Atuona.

anything different is unforgivable because the clichés needed for classification would be missing. Therefore, Gauguin was a monster— completely, imperiously. Some individuals are exceptional in only one respect; all their kinetic energy seems to

swirl around a single axis; in all other aspects of everyday life (housekeeping, courtesy calls, sense of duty), they can be conventional, ordinary. It's a question of temperament, of physical bearing. A magnificent, frenzied writer can look like a scrawny sacristan; genius by no means precludes a seemly, respectable exterior, a punctual, businesslike existence. Now, Gauguin was none of those things; in his final years he appeared to be an ambiguous, aching soul: His heart in the right place, yet ungrateful; willing to help the weak, even when they objected to it; haughty, yet with a childlike sensitivity to people's opinions and punishments, primitive and coarse; he was changeable and extreme in everything he did.

We move from the artist to his abode, the latter being merely a stage set for the former. A spare stage set with an impressive natural decor that lends a restrained, harmonious touch. A reddish-brown roof of braided leaves, forming two long slopes above a yellow partition (likewise made of plaited vegetation), is unencumbered by details; between it and the grassy ground below, a crude, unfussy, but sturdy framework fashioned from the resources of the land. In front of a short staircase leading up to the raised floor, a small, unaffected cottage shelters a dried clay model, crumbled by the rain.

It behooves us to pause here, for this is a divine effigy, and ancient rituals cannot help but bring to mind the Prayer of the Stranger: "I have come to a place where the ground beneath my feet is unknown to me. I have come to a place where the sky above my head is new to me. I have come to this land that will be my dwelling-place. Oh, Spirit of the Earth, a Stranger offers up his heart as sustenance for thee."

It is indeed a representation of the ill-defined *atua* of bygone days; but being an outgrowth of the artist's exegetic reveries, it is strangely composite. The pose is Buddha-like; but the full lips, the protruding, close-set eyes, the straight nose that barely widens at the nostrils, are native features. It looks like a Buddha from the land of the Maoris. Gauguin took pleasure in seeing the heroes of Polynesian myths assume various hieratic poses. For that he had only himself to rely on, since these peoples are loath to make representations of their deities. They are by no means unfamiliar with the art of working wood, or of carving colossal statues in lava and red sandstone, but what they fashion is limited to symbols, tabernacles, and tomb images....

Now we come to the house proper: a tiny room leading into a studio with light flooding in through an open gable. But the ornamented portal catches our eye. It is surrounded by rough-hewn yet unambiguous scenes with explanatory inscriptions and rubbed with muted colors. Overhead: *La Maison du Jouir* (House of Pleasure). To the left and right, two panels with a procession of amber-colored figures with bluish lips, striking convulsed or sluggish poses, with golden lettering that reads: *Soyez amoureuses et vous serez heureuses—Soyez mystérieuses et vous serez heureuses* ("Be in love and you will be happy—Be mysterious and you will be happy").

Then, two silhouettes of female nudes, their coarse contours like those of prehistoric figures. Lastly, two canvases attached right to the wall.

One of them shows a band of natives posing leisurely against a bright indigo

background, the ground beneath their feet a brownish ocher, almost red. A man carrying *fei* [wild bananas] is lifting onto the nape of his neck a crosspiece dripping with copious clusters of reddish-brown; the girls—their copper-colored torsos, flecked with olive, squeezed into pieces of green and yellow cloth—linger....

In this ramble of a studio, with its hodgepodge of native weaponry, there is a small, wheezing old organ, then a harp, some ill-matched furniture, and rare paintings, for the master had just finished a final batch. However, he held on to an accomplished work of long ago: a self-portrait, a portrait of sorrow, a powerful, erect torso set against a distant backdrop of what appear to be crucifixes. Thickset build, lips drawn down, eyelids heavy. A date, 1896, and a bleak epigraph: "Near Golgotha." Another, differently handled portrait, undated and unsigned, seems more timely and accurate, with its skewed pose, stocky build once again, and haughty bearing. Displayed very prominently in the studio, the most intriguing work of all: three women at rest, one of them crouching. The one on the left, carrying in a typically native way a piece of Polynesian fruit, is seen from behind, turned halfway round, the weight of her body on her right leg. The second, her legs doubled up beneath her, is suckling a child. In both the treatment is broad and simple, their expressions utterly Tahitian. The third stands apart from them and recalls the poses Puvis de Chavannes was so fond of. All against a bipartite backdrop of earth and sky: dark green ground, a bright, pale green sky, a becalmed evening sky that harmonizes with the poses of the unhurried threesome.

And, in a final paradox, the work to which this dying man devoted his final brushstrokes in this land of light: a chilling view of Brittany, glints of snow melting on thatched roofs beneath low-lying clouds scored by scrawny trees.

Gauguin did not die a leper. Anyway, it is pointless to give you a rundown of his predispositions to disease, for a good deal more than that was involved. They were aggravated by inner conflicts, by setbacks. Childish conflicts that wore this magnificent fighter down with trivial disputes, "legal" setbacks which this pure artist oddly took so much to heart, like so many falls from grace. As if human justice could sully those whom genius elevates to dispossessed, directionless Outlaws!

The "extras" that (languidly) bestirred themselves around Gauguin were the pale, slender Marquesans, with bluish streaks across their faces, making their eyes look deeper-set and their mouths inordinately large; etched into their clear skin, a raiment of symbolic tattoos, each decoration (in olden times) standing for a feat of arms. Gauguin the choryphaeus intoned the recriminatory lament; his docile chorus concluded the antistrophe. Many followed him uncomprehendingly, these giant children who, in order to express our customs, had to encumber their language with Semitic or Latin roots, dead letters for them. A few provoked him with misinformation, but still other natives were genuinely decent and faithful....

Finally, the time and place of the action: "The present, island of Hiva-Oa, district of Atuona." Panoramic backdrop: the mighty downthrust, straight into a pleasant valley, of a gigantic wall of rock scored by

extinct, belched out long, long ago.

And within these unyielding confines, a tangle of green masses, of ocher palms quivering in the wind, of branching colonnades hoisting crowds of blossoms toward the light. Everywhere the sound of water: bursting down mountainsides, soaking the ground, snaking along riverbeds of smooth pebbles. Everything is alive, everything thrives in the scented warmth of summers hardly ever visited by drought—everything except the human race. For those pale, svelte Marquesans are on their last legs; they are dying. Without sorrow or wailing or reproach, they are wending their way to their impending demise. Again, what would be the use of pompous diagnoses? Opium has left them emaciated; terrible fermented juices have corroded them with newfound intoxication; consumption has made them hollow-chested; syphilis has left them sterile. But all these things are but the various guises of that other scourge: contact with "civilization." Twenty years hence they will have ceased to exist as "savages." In the process, they will have forever ceased to exist.

N*ativity*, 1899.

Now these magnificent valleys leading into the barren heart of the islands look like pathways of the dead. Lined with sagging wooden houses on crumbling stone terraces, strewn with sacred *pae-pae* where victims were once sacrificed in basalt enclosures, they have witnessed the death of the aboriginal gods, then of men. And, so, one cool, cloudless morning, Gauguin died there, too. Tioka, his faithful friend, crowned him with fragrant blossoms and, according to custom, rubbed his body with monoï oil, then sadly proclaimed, "Now, there are no more men."

glistening threads of waterfalls, its peak lopped off by a horizontal bar of stagnant, perpetual clouds, leveling its serrated ridges. The islands are named after these jagged crests: Grand Crest, Crest-over-the-Cliff, Crest-over-the-Crag. Set into the rockfaces are corpses which the natives honor by nestling them in almost aerial hiding places reached by improbable paths. Framework of the set: foothills which hem in every valley on the right and left clear down to the shore, valleys which the sea obstructs with still more crests—the crests of breaking waves. For there is no protecting reef, that soothing reef of lifeless oceanic beaches. Here the sea is alive, thrashing, eroding. The ocean surges into the bay, rolls over brown or golden beaches, laps up against lava flows that craters, now

Concise Glossary of Gauguin's Views and Moods

Culled from his writings on art, artists, and various other subjects.

de en le moment .

vous demander un

ut marcher), mes l

tes —

and merci d'avan

Paul Gauguin

Excerpt of a letter from Gauguin to Daniel de Monfreid.

Abstraction

A word of advice: Don't copy nature too literally. Art is an abstraction. Derive it from nature as you dream in nature's presence, and think more about the act of creation than the outcome.

To Schuffenecker,
Pont-Aven, 14 August 1888

Androgyny

If…you want to be somebody, if you would find happiness solely in your independence and your conscience…, you must regard yourself as androgynous, sexless. By that, I mean that heart, soul, in short, all that is divine, must not be a slave to matter, that is, to the body.

To Madeleine Bernard,
October 1888

Aristocracy

Intuitively, instinctively, spontaneously, I love nobility, beauty, refined taste, and that motto of a bygone age, noblesse oblige. I love good manners, courtesy—even that of Louis XIV. Therefore (instinctively and not knowing why), I am an aristocrat. As an artist. Art is just for a minority; it must itself be aristocratic. The only people that were patrons of art were noblemen, instinctively, or because they felt it was their duty, or perhaps out of vanity. No matter: They commissioned great and beautiful creations. Kings and popes used to treat artists as equals, as it were.

Democrats, bankers, ministers, and art critics go through the motions of being patrons of art, but don't follow through. They haggle away like customers at a fish market. And you would have artists be republicans!

Cahier pour Aline

Brittany

I love Brittany. There is something wild and primitive about it. When my wooden clogs strike this granite ground, I hear the dull, muffled, powerful tone I seek in my painting.

To Schuffenecker,
Pont-Aven, February 1888

Ceramics

Making ceramics is not an idle pursuit. Ages and ages ago, this art was continually in favor among the American Indians. God created man with a little mud. With a little mud you can make metal and precious stones—with a little mud and a little genius!

Notes sur l'Art à l'Exposition Universelle

Cézanne

Mr. Critic, you don't for a minute suppose that you discovered Cézanne! Today you admire him. Admiring him (which requires comprehension), you say, "Cézanne is monochromatic." You could have said polychromatic, even polyphonic. Use your eyes and your ears!…"Cézanne is beholden to no one. He is satisfied with just being Cézanne!" There's some mistake, otherwise he wouldn't be the painter he is. Unlike Loti, he is well-read. He is versed in Virgil. He has looked at Rembrandt and interpreted Poussin with real understanding.

Racontars de Rapin

Color

Being in itself enigmatic in terms of the sensations it gives us, color cannot be logically used except enigmatically, each and every time one uses it, not to draw, but to create musical sensations that issue from color itself, from its own character, from its mysterious, enigmatic inner force. Symbols are created by means of skillful harmonies. Color, which, like music, is vibration, captures that which is most general and, consequently, most elusive in nature: its inner force.…

Diverses Choses

Corot

I also lingered over Corot's nymphs dancing in the woods of Ville-d'Avray. Without having done any studies of

B*athers in Brittany*, from the *Volpini Suite*, 1889.

dancers at the Opéra, with utmost naiveté and sincerity, this delightful Corot knew how to make all those nymphs dance, and, in misty horizons, how to transform all the little country homes of suburban Paris into veritable pagan temples. He liked to dream, and in front of his paintings I dream as well.

Diverses Choses

Degas

I'm very happy that you met Degas and that, while trying to help me, you yourself managed to make some good connections. That's right, Degas is thought to be caustic and objectionable (so am I, according to Schuffenecker).

But such is not the case for those whom Degas deems worthy of his attention and estime. He is naturally kind-hearted and he is intelligent....In terms of both talent and conduct, Degas is a rare example of all that an artist should be. He has had as colleagues and admirers all those who are in power: Bonnard, Puvis, etc., Antonin Proust...yet, never asked for anything. No one has ever seen him or heard of his doing anything underhanded or tactless or mean-spirited. Art and dignity.

To Monfreid,
Papeete, 15 August, 1898

He respects Ingres, which means he respects himself. In appearance, with his silk hat and blue spectacles, he is the very picture of a notary, a bourgeois from the time of Louis-Philippe, right down to the umbrella.

If there exists a man who cares little about looking like an artist, it is certainly he; he is so much of one. Then again, he loathes all uniforms, even that one. He is kind-hearted, but being witty he is thought to be ill-natured. Ill-natured and spiteful. Is that the same thing?

A young critic who is forever expressing his opinions as though they were the foretellings of an augur, once said, "Degas, that kindly old curmudgeon!" Degas a curmudgeon! A man who carries himself like an ambassador at court when he walks down the street! Kindly! How very trite. He's better than that....

Ah, I see what he means! A curmudgeon. Degas doesn't believe in interviews. Painters seek his approval, ask for his opinion, and that curmudgeon, that surly man, to avoid saying what he really thinks, says to you very pleasantly, "Forgive me, but I can't see very well. My eyes, you know...."

On the other hand, he doesn't wait until you're famous. He has a sixth sense about the young; he is so knowledgeable, yet never mentions a lack of knowledge in others. While saying to himself, "Surely he'll learn

E_dgar Degas.

later on," he says to you, like a nice old gentleman, as he did to me when I was starting out, "You are well on the way to success."

He is one of the greats, yet never feels put out by anyone.

Avant et Après

Delacroix

It is surprising that Delacroix, who is so totally wrapped up in color, rationalizes it as a law of physics, a way of imitating nature. Color! Language of dreams, so profound, so mysterious. I detect in all his work a hint of a mighty struggle between that dreamy nature of his and the pedestrian nature of the painting of his era. His instinct rebels in spite of himself; time and again he rides roughshod over those laws of nature and gives in completely to his imagination.

Diverses Choses

Send me a photo of Delacroix' *Shipwreck of Don Juan*, but only if it doesn't cost too much. I confess that only at times like these do I feel able to shut myself up in the house of art. Have you noticed how much of the wild beast there was in this man's temperament? That's why he was so good at painting them. Delacroix's draftsmanship always reminds me of the powerful, yet supple movement of a tiger. The musculature of this superb animal defies analysis; its paws seem impossibly contorted, yet, that's the way they are in real life. The same with Delacroix: His arms and shoulders are always twisted round so wildly, they defy rationalization; and yet, they express real-life passions.

His draperies coil like a snake, yet they're tiger-like! Be that as it may and regardless of what you may think, the shipwreck of his Don Juan is the inspiration of a powerful monster, and I'd very much like to feast my eyes on this spectacle once more. All those starving people out there on that sinister sea…. Hunger is the great leveler. All that's left is painting; no simulation of reality. The ship is a plaything that was not built in any seaport. Monsieur Delacroix may not be a seaman, but what a poet! Upon my word, he is quite right not to ape Gérôme, with his archaeological exactitude.

To Schuffenecker,
24 May 1895

The Eiffel Tower and Cast-Iron Architecture

Obviously this exposition marks the triumph of iron, not only from the

Eugène Delacroix, *Self-Portrait.*

standpoint of machinery, but from the standpoint of architecture. Yet, architecture is in its initial stages in that it lacks in [the realm of] art a form of decoration consistent with its materials. Why this overlay of soft materials, like painted terra-cotta, on this stern, rugged iron? Why apply that tired old stock of tired old ornaments, updated by naturalism, to this new breed of geometric contours? Engineer-architects have a new kind of decorative art all their own—decorative bolts, projecting iron chocks, a kind of Gothic tracery in iron. There's a bit of that in the Eiffel Tower.

Simulated bronze statues do not go with iron. And the imitations keep on coming! Bolted iron monsters would be an improvement.

Why does iron have to be given an overlay of pretty paint? Why all that gilding, the kind you see at the Opéra? No, that is not in good taste. Iron, iron, bring on the iron! Use colors as solemn as the material itself, and you'll end up with an imposing structure, one which suggests molten metal.

Notes sur l'Art
à l'Exposition
Universelle

Flying Dutchman

With form and color, what lofty thoughts can we call forth! How safe and sound they are on land, those conventionalists with their trompe l'oeil of nature! We alone are sailing aboard a Flying Dutchman, with all our quirky imperfections. How more tangible infinity seems to us when we look at something ill-defined. Musicians delight in sound, but we—

with our insatiable, lusting eyes—we revel in endless delights.

To Schuffenecker,
Pont-Aven, September 1888

Government Support

[Schuffenecker] has—needlessly, I feel—just petitioned the government to come to my assistance.

Nothing could offend me more. I ask that friends help me out until such time as I can recover the money owed me and that they do what they can to collect it—but it was never my intention to beg from the State. The day that happens, everything I've struggled to do outside officialdom, the dignity I've done my utmost to maintain throughout my life, will lose its mettle.

To Monfreid,
August 1896

Greek Art

You will always find nourishment in the primitive arts. (In the arts of mature civilizations, nothing, except repetition.) When I studied the Egyptians, there was always a healthy something going on in my brain; whereas studying Greek art, especially in its decadent phase, prompted loathing or dejection, a vague feeling of death without any hope of rebirth....

Always keep in mind the Persians, the Cambodians, and, a little, the Egyptians. Greek [art] is seriously flawed, however beautiful it may be.

To Monfreid,
Tahiti, October 1897

Hokusai

In this warrior by Hokusai do you not see the aristocratic bearing of Raphael's *Saint Michael*, the same purity of line,

combined with the power of Michelangelo, and, for all that, a much simpler technique, without the play of light and shadow? So far from nature, yet so close to it. There is certainly no need to dwell on the nobility and directness of his draftsmanship; they are obvious to anyone with an

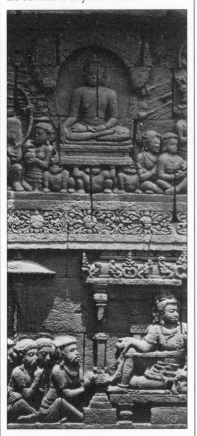

Relief carvings, Temple of Borobudur, Java.

instinctive feeling and love for those primordial qualities.

Diverses Choses

Impressionism

I, an Impressionist artist, that is, an insurgent…Then came the Impressionists! They were the ones who pored over color to the exclusion of all else, as a decorative effect, but not freely, still shackled by verisimilitude. For them, imaginary, make-believe landscapes do not exist. They looked, and what they saw was harmonious, but purposeless: The house [the Impressionists] built had no real foundation rooted in, and justified by, sensations perceived through color.

They focused their quest on the eye, not on the mysterious center of thought, and from there lapsed into scientific considerations. Physics and metaphysics are two different things.…They were dazzled by their initial triumph and thought there was nothing more to it than that. They are the officials of tomorrow, more terrifying than the officials of yesteryear.

Diverses Choses

Mandolin

I came up with the bright idea of bringing along my music and my mandolin; they're a great diversion for me. Filiger put that bee in my bonnet, to play this instrument. In terms of virtuosity, I don't think Filiger could hold a candle to me now.

To Sérusier,
Tahiti, November 1891

Manet

I also remember Manet. Another who didn't feel put out by anyone. Once, when he saw a picture of mine (I was

just starting out), he told me it was very good. "Oh, I'm just an amateur," I replied out of respect for the master. I was working for a stockbroker at the time and studying art nights and holidays.

"No indeed," Manet said. "The only amateurs are the ones who paint badly."

How pleasant that was to hear.

Avant et Après

Moreau

By way of contrast with this criticism, Huysmans speaks of Moreau with the very deepest respect. Fine. We respect him, too, but just how much? Here we have an essentially unliterary man with a desire to be literary.

Thus, Gustave Moreau only speaks a language which has already been set down by men and women of letters; in a way, he is an illustrator of old stories. The driving force behind his work is nowhere near the heart; and he loves the opulence of material possessions. He's crammed full of them. He turns every human being into a jewel bedecked in jewels. In short, Moreau is a fine engraver.

Huysmans and Redon

Music and Painting

In the art of literature there are two contending parties. Those who aim to tell stories that are more or less well thought out, and those who aim at beautiful language, beauty of form. This contest may last a very long time; each side has a fifty-fifty chance. Only the poet can rightfully demand that verse be beautiful and nothing but.

Musicians are special. Sounds, harmonies. Nothing else. They live in a world all their own. Painting, too, should be in a class by itself. Music's

sister, it lives on forms and colors. Those who thought otherwise are on the brink of defeat.

Cahier pour Aline

Oriental Carpets

I still have to discuss color solely from the standpoint of art. Color alone, as a language of the listening eye, and its power to suggest....

Orientals and Persians, among others, printed above all a complete dictionary of this language of the listening eye; they endowed their carpets with marvelous eloquence. You painters who clamor for a color technique! Study those carpets, and they will tell you all you want to know; but who can tell, the book might be sealed and you won't be able to read it. Then the memory of bad traditions gets in your way.

From this kind of color— definite in its inherent charm, yet indefinite as an indicator of objects perceived in nature—there arises a disconcerting question, "What can that possibly mean?" that defies analysis. What does it matter?

Diverses Choses

Paradise

Out there at least, with winterless skies overhead and wonderfully fertile ground underfoot, Tahitians only have to lift their arms to gather their food; therefore, they never work. Whereas in Europe men and women satisfy their needs only after ceaseless toil, contending all the while with convulsions of cold and hunger, prey to poverty.

The Tahitians, blessed inhabitants of Oceania's unknown paradises, know only the sweet things life has

G ustave Moreau, preliminary drawing for *The Triumph of Alexander the Great.*

to offer. For them, life is singing and loving.

To Willumsen,
late 1890

Pissarro

If you survey the whole of Pissarro's output, its variations notwithstanding —Vautrin is always Vautrin, despite his many incarnations—you will find not only a consistently high degree of artistic control, but an essentially noble, intuitive art. However far away that haystack on yonder hillside may be,

Pissarro knows how to take the trouble to look it over, to scrutinize it. He's observed everybody, you say? And why not! Everybody's observed him, too, but disowned him. He was one of my teachers, and I for one do not disown him.

There's a charming fan of his, in a display cabinet. A simple, half-opened gate separating two very green (Pissarro green) meadows, and passing through it a gaggle of geese nervously looking about as they ask themselves, "Are we heading toward Seurat's or Millet's?" They all end up waddling off to Pissarro's.

Avant et Après

Polynesian Beauty

A Polynesian woman could never be tawdry or ridiculous, for there is within her that sense of decorative beauty that I have come to admire in Marquesan art, now that I have studied it. But isn't there something more to it? Something more than a pretty mouth that reveals equally pretty teeth when it smiles?…Or those lovely, golden-nippled breasts, so ill-suited to corsets? The thing that distinguishes the Polynesian woman from all others, and which often causes one to mistake her for a man, is the way her body is proportioned. A Diana the Huntress with broad shoulders and narrow hips.…

The legs of Polynesian women, from hip to foot, form lovely straight lines. Their thighs are nicely fleshed out but not wide, which makes them look very full and spares them that separation which has caused [the legs of] some of our European women to be likened to a pair of tongs.

Their skin is golden yellow, needless

Odilon Redon, *The Eye as a Bizarre Balloon*, lithograph, 1822.

to say, and that's ugly for some, but in other respects, especially when naked, are they as ugly as all that?

Avant et Après

Poverty

I have known extreme poverty, that is, what it is to be cold, hungry, all that goes with it. It's nothing, or hardly anything.

You get used to it, and with a little willpower you end up making light of it. But the thing that's awful about poverty is that it prevents you from working, from developing your intellectual faculties. Especially in Paris, where, as in all big cities, the race for money eats up three-quarters of your time and half of your energy. On the other hand, suffering whets the genius in you. Not too much, though, or it'll do you in.

Cahier pour Aline

The Present

I'll let you in a little on my secret. It is eminently logical, and I go about it methodically. From the outset, I knew that I'd be living from hand to mouth, so it followed that I should condition my temperament accordingly. Instead of using up my energy fretting about what the next day might bring, I concentrated all my energy into the present, like a wrestler who keeps his body still until the bout gets under way. When I go to bed at night, I say to myself: Another day gained; tomorrow I may be dead.

To Monfreid,
11 March 1892

Pride

With a great deal of pride I ended up with a great deal of energy and the willpower to do things my way! Is pride a flaw, and should it be developed? I think so. There's still nothing like it for struggling against the human beast within us.

Cahier pour Aline

Redon

I do not see how Odilon Redon creates monsters. They are imaginary beings. He is a dreamer, a man who imagines. Ugliness: a ticklish question, the touchstone of our modern art and its criticism. If we take a close look at Redon's profound art, we find little it in that is "monstrous," no more so than in the statues of Nôtre-Dame. To be sure, animals we don't normally see look like monsters, but that's because of our tendency to recognize nothing as genuine and normal except the run-of-the-mill majority.

Nature is mysteriously infinite and has great powers of imagination. She is

Auguste Renoir,
Portrait of Richard Wagner, 1883.

continually varying her displays. The artist himself is one of her vehicles, and, to me, Odilon Redon is someone she has chosen to keep this process of creation alive. In his work, dreams turn into reality because he makes them so believable. All of his plants, those essentially human embryonic beings, have lived with us; surely they have had their share of suffering.

In the gloom, we can make out one or two tree trunks; there's something on top of one of them, probably a man's head. In an extremely logical way, he leaves us in doubt about this life form. Is it really and truly a man, or a vague semblance of one? Whichever it is, both of them are alive on that page, inseparable, weathering the same storms.

And what about that human head with its hair on end, the skull partly opened to reveal a huge eye? Is it a monster? No! In the stillness, the night, the dark, our eyes see, our ears hear....All I see in his entire oeuvre is a language of the heart, quite human, not monstrous.

Huysmans et Redon

Renoir

A painter who never learned to draw, yet draws well—that's Renoir....

In Renoir's work everything is out of line: in fact, don't look for lines; there aren't any. As if by magic, a lovely patch of color, an affectionate glimmer of light are expression enough. On the cheeks, as on a peach, a faint overlay of down ripples in a breeze of love that wafts its music to your ears. One would like to take a bite out of that cherry of a mouth, which, when it smiles, pearls those pointy little white teeth. Watch out, though—it has a cruel bite; those

are women's teeth. Divine Renoir, who knows not how to draw....

I saw a strange head at an exhibition on the Boulevard des Italiens. I don't know why, but I felt something happen inside of me. Why did I hear strange melodies while I looked at a painting? An ashen, scholarly head with eyes that don't stare at you, eyes that don't look, but listen.

I read in the catalogue: *Wagner* by Renoir. Enough said.

Avant et Après

Savagery and Solitude

Having lost all their savagery, having run out of instinct and, you might say, imagination, artists have wandered down all sorts of paths, looking for productive elements they themselves did not have the strength to create and, consequently, act only as disorderly crowds, feeling timid and at a loss when they're on their own. That is why solitude should not be recommended to everyone; you've got to have the stamina to withstand it and act on your own. Everything I've learned from others has hindered me. I can there-fore say: No one has taught me anything; and I know so little! But I prefer this little which is mine and mine alone. And who can tell if that little, cultivated by others, won't turn into something great?

Racontars de Rapin
Atuona, Marquesas Islands,
April 1903

Symbolism

You know what I think about all those misconceptions about Symbolism, both in literature and painting, so there's no need to repeat them. Besides, we see eye

to eye on this subject, and so will posterity, since sound works of art have endured in spite of everything, and all those critico-literary lucubrations haven't made a bit of difference. I congratulate myself, perhaps too arrogantly, on not having fallen into all those bad habits into which an adulatory press would have liked to lead me, as it has so many others. Denis, for one; Redon, too, perhaps. And, although bored, I'd smile whenever I read all those critics who failed to understand me.

<div align="right">

To Monfreid,
Atuona, November 1901

</div>

The Unknown

In three days I'm going back to Pont-Aven, because I've run out of money

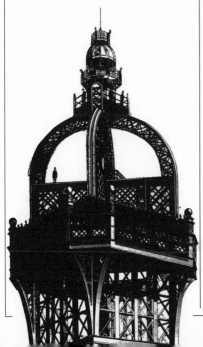

and I can live there on credit. I intend to stay there till winter, at which time, if I can get some job or other in Tonkin, I'll run off to study the Annamites. Terrible itching for the unknown that makes me do things I shouldn't....

<div align="right">

To Emile Bernard,
Le Pouldu, August 1889

</div>

Vanity

Be proud as you do everything you can to win the right to be proud, and do your best to earn your own living, which is a path to that right. But do away with Vanity, which is the hallmark of mediocrity, including the vanity of money.

<div align="right">

To Madeleine Bernard,
October 1888

</div>

Weakness

Many people always find support because their weakness is known, and they know how to ask. No one ever helped me because people think I'm strong, and I was too proud. Now I am weak, prostrate, half exhausted by the ruthless struggle I have entered into. I fall down on my knees and cast aside all pride. I am nothing but a failure.

<div align="right">

To Monfreid,
Tahiti, April 1896

</div>

Women

Women want to be free. That is their right. But surely men are not the ones standing in their way. The day they stop situating their virtue below their navels, they shall be free. Perhaps healthier, too.

<div align="right">

Cahier pour Aline

</div>

Beacon atop the Eiffel Tower.

Further Reading

Writings by Paul Gauguin

Ancien Culte Mahorie, ed. René Huyghe, postscript by René Huyghe, La Palme, Paris, 1951; Hermann, 1967

Avant et Après, Paris, 1923. (*The Intimate Journals of Paul Gauguin*, New York, 1923, 1936)

Cahier pour Aline, ed. Suzanne Damiron, Société des Amis de la Bibliothèque d'Art et d'Archéologie de l'Université de Paris, Paris, 1963. Facsimile edition with commentary by the editor

Correspondance de Paul Gauguin (1873–1888), ed. Victor Merlhès, Fondation Singer-Polignac, Paris, 1984

Lettres de Gauguin, Gide, Huysmans...à Odilon Redon, eds. Rosaline Bacou et Ari Redon, Corti, Paris, 1960

Letters of Paul Gauguin to Georges-Daniel de Monfreid, The, trans. Ruth Pielkovo, Dodd Mead, New York, 1922

Lettres de Paul Gauguin à sa femme et à ses amis, ed. Maurice Malingue, Paris, 1946; revised expanded edition, Paris, 1949

Noa Noa, Paris, 1954. Facsimile edition of Gauguin's unillustrated, unannotated manuscript. (Paris, c. 1893–4), originally presented to Charles Morice

Noa Noa, ed. Pierre Petit, Paris, 1988

Noa Noa, Gauguin's Tahiti, ed. Nicholas Wadley, Phaidon, London, 1985

Noa Noa, Voyage de Tahiti, Berlin, n.d. (1926); reprint, Stockholm, 1947. Facsimile edition of illustrated manuscript presented to the Louvre in 1925 by Daniel de Monfreid

Noa Noa, Voyage to Tahiti, Oxford, 1961

Oviri, écrits d'un sauvage, ed. Daniel Guérin, Gallimard, Paris, 1974

Paul Gauguin, A Sketchbook, eds. Raymond Cogniat and John Rewald, Paris and New York, 1962. Facsimile edition of sketchbook, c. 1884–8, Armand Hammer Collection, including Gauguin's essay *Notes synthétiques* (1885)

45 Lettres à Vincent, Theo et Jo van Gogh, ed. Douglas Cooper, La Bibliothèque des Arts, Lausanne, 1983

Racontars de Rapin, Falaise, Paris, 1951

Monographs

Cachin, Françoise, *Gauguin*, Hachette, Paris, 1968; Flammarion, Paris, 1988; Hachette Pluriel, Paris, 1989

Chassé, Charles, *Gauguin sans légendes*,

Les Editions du Temps, Paris, 1965

Danielsson, Bengt, *Gauguin in the South Seas*, trans. Reginald Spink, Doubleday, Garden City, N.Y., 1966

Hoog, Michel, *Paul Gauguin: Life and Work*, New York, 1987

Huyghe, René, *Gauguin*, Flammarion, Paris, 1979

Leprohon, P. *Gauguin*, Gründ, Paris, 1975

Malingue, Maurice, *La Vie Prodigeuse de Gauguin*, Buchet-Chastel, Paris, 1987

Morice, Charles, *Paul Gauguin*, Paris, 1920

Perruchot, Henri, *La Vie de Gauguin*, Hachette, Paris, 1961; Le Livre de Poche, 1963

Rotonchamp, Jean de, *Paul Gauguin*, Weimar, 1906; Paris, 1925

Thomson, Belinda, *Gauguin*, Thames and

Hudson, London, 1987

Catalogues of Works and Exhibitions

Brettell, Richard, Françoise Cachin, Claire Frèches Thory, Charles F. Stuckey, *The Art of Paul Gauguin*, catalogue of exhibition, 1988–9

Gray, Christopher, *Sculpture and Ceramics of Paul Gauguin*, The Johns Hopkins Press, Baltimore, 1963

Kornfeld, Eberhard, Harold Joachim, Elizabeth Morgan, *Paul Gauguin: Catalogue Raisonné of His Prints*, Bern, 1988

Sugana, G. M., *Tout l'oeuvre peint de Gauguin*, Rizzoli, Milan, 1972; Flammarion, Paris, 1981

Wildenstein, Georges, *Gauguin*, eds. Raymond Cogniat and Daniel Wildenstein, Vol. 1, Catalogue, Les Beaux Arts, Paris, 1964

List of Illustrations

Index

Photograph Credits

Agence de Presse Novosti, Paris: 51b, 120–1. Albright-Knox Art Gallery, Buffalo: 58b, 84–5. Archiv für Kunst und Geschichte, Berlin: 52–3, 54–5, 97bl. Archives E.R.L./Sipa Icono, Paris: 58, 128–30, 143r, 158. Archives Sirot-Angel, Paris: 62–3, 63, 68a, 68b, 69, 79b, 106, 157, 166. Art Institute of Chicago: 50–1, 70, 80, 184. Artephot/Bridgeman: 42–3, 66, 114–5, 125, 126. Artephot/Cercle d'Art: 108. Artephot/Fopler, 88–9. Artephot/Held: 122–3, 124a. Artephot/Hinz: 20a. Baltimore Museum of Art: front cover, 95. Bibliothèque d'Art et d'Archéologie, Jacques Doucet Foundation, Paris: 93, 137, 141, 177. Bibliothèque Nationale, Paris: 43, 43r, 45, 169r,

178, 181, 185. E. G. Bührle Foundation Collection, Zurich: 16b. Bulloz, Paris: 40–1. J. L. Charmet: 12, 14, 162. Cleveland Museum of Art: 60a, 73b. Coll. Mr. and Mrs. Walter Annenberg: 71. Coll. Jean-Pierre Bacou: 31b. Coll. Dr. and Mrs. Martin Gecht: 99b. Coll. Josefowitz: 22a, 29a, 34, 47. Dagli-Orti, Paris: 107a. Edimedia, Paris: 105. Giraudon, Paris: 38, 94l. Giraudon/Archives Larousse, Paris: 94r. Giraudon/Lauros, Paris: back cover, 59, 65l. Harvard University Art Museums (Fogg Art Museum), Cambridge: 19a, 152. Kunstindustrimuseet, Copenhagen: 64b. Kunstmuseum, Basel: 127. Metropolitan Museum of Art, New

York: 115. Musée de la Marine, Paris: 15b. Musée de l'Homme, Paris: 13a, 30a, 57b. Musée Départemental du Prieuré, Saint-Germain-en-Laye: 15al, 15ar, 21a, 35a, 107b, 138. Musées Royaux d'Art et d'Histoire, Brussels: 39. Nasjonal Galleriet, Oslo: 18, 20bl. National Gallery of Art, Washington: 25, 46, 76. National Gallery of Canada, Ottawa: 65r. National Galleries of Scotland, Edinburgh: 32. Neue Pinakothek, Munich: 24, 28, 110–1. Ny Carlsberg Glyptotek, Copenhagen: 17b, 19b, 74. Oeffentliche Kunstsammlung, Kunstmuseum, Basel: 73, 90. Ohara Museum of Art, Kurashiki: 77a. Ordrupgaardsamlingen, Copenhagen: 56–7, 109a, 109b. Private collections:

9, 21b, 30–1, 92, 99a, 175. Réunion des Musées Nationaux, Paris: spine, 1–7, 16–7, 22b, 23, 26, 29b, 33, 37, 60b, 61, 62a, 64–5, 72, 77b, 79a, 82, 83, 86–7, 91, 96, 97al, 100, 102, 103, 104, 112, 113a, 113b, 117a, 118–9, 131–2, 164–5, 172, 179, 183. Rights reserved: 11, 20lr, 31a, 35b, 49, 52a, 52b, 62b, 67, 81a, 85b, 97ar, 98, 101l, 116, 118a, 118b, 124b, 133, 139, 143l, 147, 148, 169l, 170, 187. Rijksmuseum Vincent van Gogh (Vincent van Gogh Foundation), Amsterdam: 48, 155. Roger-Viollet, Paris: 13b 101r. Roger-Viollet/ Harlingue, Paris: 27, 161. Saint Louis Art Museum: 117b, 151. Scala, Florence: 36. Staatsgalerie, Stuttgart: 10. Peter Willi, Paris: 38–9, 44, 78

Acknowledgments

The publishers thank the following individuals: Marie Amélie Anquetil, Curator, Musée du Prieuré, Saint-Germain-en-Laye; Isabelle Wolf, Photograph Department, Réunion des Musées Nationaux; Nathalie Michel, Réunion des Musées Nationaux; and the many private collectors who so graciously gave their permission to reproduce certain works of art.

Text Credits

Grateful acknowledgment is made for use of material from the following works:

Danielsson, Bengt (trans. Reginald Spink), *Gauguin in the South Seas*, Doubleday, Garden City, New York, 1966 ("Interview with Paul Gauguin")

Hartrick, Archibald Standish, *A Painter's Pilgrimage through Fifty Years*, Cambridge University Press, Cambridge, 1939

Prather, Marla and Charles F. Stuckey, eds., *Gauguin: A Retrospective*, © 1987, Hugh Lauter Levin Associates, Inc. ("Strindberg and Gauguin")

Françoise Cachin is the director of the Musée d'Orsay, Paris,
and has organized many exhibitions in Europe and the
United States. She has written widely on a variety of artists,
including Gauguin, Manet, Signac, and Degas.

Translated from the French by I. Mark Paris

Project Manager: Sharon AvRutick
Typographic Designer: Elissa Ichiyasu
Design Assistant: Catherine Sandler
Text Permissions: Catherine Ruello
Editorial Interns: Sibyl Ehresmann, Caroline Jones

Library of Congress Catalog Card Number: 91–75504

ISBN 0–8109–2800–0

Copyright © Gallimard 1989

English translation copyright © 1992 Harry N. Abrams, Inc.,
New York, and Thames and Hudson Ltd., London

Published in 1992 by Harry N. Abrams, Incorporated, New York
A Times Mirror Company

Printed and bound in Italy by Editoriale Libraria, Trieste